FUSING TRADITIONS

Transformations in Glass by Native American Artists

Carolyn Kastner, Editor

With Essays by
Roslyn Tunis, Preston Singletary, Kate Morris and Lloyd E. Herman

MUSEUM OF CRAFT & FOLK ART

Landmark Building A, Fort Mason Center, San Francisco, California 94123-1382 TEL: 415.775.0991 FAX: 775.1861

The mission of the Museum of Craft & Folk Art is to foster an appreciation of the artistic qualities of contemporary craft and recognition of the vigor and richness of folk art from diverse cultures through exhibitions, educational programs and research publications.

TABLE OF CONTENTS

LARRY AHVAKANA

Cultural lineage is a difficult line to

MARCUS AMERMAN

draw for many of us who do not

BRIAN BARBER

have a specific known heritage. Yet I

MICHAEL CARIUS

believe we all share in a collective

JOE DAVID

consciousness that keeps us connected.

JOHN HAGEN

These Native Americans working in

CONRAD HOUSE

an ancient material are able to draw

CLARISSA HUDSON

upon direct personal history and

TONY JOJOLA

relationships that link directly to

RAMSON LOMATEWAMA

their origins. Whether their ideas

ED ARCHIE NOISECAT

are interpreted through a contemporary

MARVIN OLIVER

vision or an ancestral memory, it

SHAUN PETERSON

draws upon the same source. Their

SUSAN A. POINT

intuitive response to objects links them

WAYNE G. PRICE

to the timeless. Since we know some-

PRESTON SINGLETARY

thing about the history of the Native

DAVID SVENSON

American culture, their works allow

ROBERT JOHN TANNAHILL

us the opportunity to rise out of the

C. S. TARPLEY

entropy that threatens our identity.

WILLIAM MORRIS, 2002

ACKNOWLEDGEMENTS

We have been blessed with the help of many people while developing this catalogue and exhibition. First, we thank Janeen Antoine of American Indian Contemporary Art for introducing us to each other, as we each began to curate an exhibition of Native American glass art in the fall of 2000. At our first meeting, we agreed to collaborate and immediately began to plan this exhibition. Special thanks go to Preston Singletary, Curatorial Consultant to this project, for his generous and wise council at every stage of the project. We are indebted to him for sharing his cultural and artistic knowledge, which expanded the scope of the project and enriched the exhibition immeasurably.

The exhibition is a glorious presentation of fragile objects that came to us from every part of the United States and British Columbia. We are grateful to many people for their efforts in identifying and shipping the precious artwork that made this exhibition possible. Without the assistance of John Bridges, the artwork of Conrad House would not have been included. Stonington Gallery in Seattle, Kiva Fine Arts in Santa Fe, Alaska Indian Arts, Inc. in Haines, and Inuit Gallery in Vancouver packaged and shipped art to us safely, and supplied us with the photographs necessary to complete the catalogue.

This catalogue is the product of the creative staff at the Museum of Craft & Folk Art, who have strengthened the project with their generous and thoughtful contributions. We thank them and intern Christine Chang for their assistance in producing this catalogue. Thanks also to the the staff at several museums, we are able to make meaningful comparisons between the past and present. Historical photographs appear courtesy of: Alaska State Museum, Juneau, Steve Henrikson, Curator of Collections; Museum of Anthropology, University of British Columbia, Jennifer Webb, Communications Manager; Phoebe A. Hearst Museum of Anthropology, University of California at Berkeley, Therese Babineau, Senior Museum Photographer, Joan Knudson, Museum Registrar, and Karen Bruhns.

Roslyn Tunis thanks Cyril Tunis and Karen Silverberg. Carolyn Kastner thanks John and Pam King, who furthered this project with their gifts of knowledge and art. Finally and most profoundly, we thank Lee Fatherree for his exquisite photography and Ron Shore of Shore Design for pulling all of our thoughts and hopes into this beautifully and sensitively designed catalogue.

CAROLYN KASTNER AND ROSLYN TUNIS, Co-curators

FOREWORD

The Museum of Craft & Folk Art has a history of exhibiting objects that result from the impact of diverse cultures blending. *Innerskins/Outerskins: Gut and Fishskin* and *Shibori: Tradition and Innovation—East to West* and now, *Fusing Traditions: Transformations in Glass by Native American Artists* reverse a trend in many museums of exhibiting fine art objects influenced by European artists and craftspeople. In the current exhibit, *Fusing Traditions*, American artists have turned inward, using the studio art methods, initially implemented by the American Studio Glass Movement, to create works of art inspired by objects of use and ritual.

Studio glass blowing is a relatively new artistic expression. For most of the long history of glass making, glass has been produced by artisans trained through apprenticeship, working with a master craftsman. Production has emphasized consistency, not innovation. Nor were the great masters of Venice willing to share techniques with visiting Americans. Since the middle of the 20th century, however, there has been a highly original group of glass artists working in this country who use private studio spaces equipped with single furnaces to create spontaneous glass art. Characteristically they have studied in studio art programs and are familiar with the history of fine arts, as well as the ancient methods of molding and blowing glass. Parallel but marginalized has been a movement among Native American artists working in glass. The Museum of Craft & Folk Art proudly presents these artists for the first time, thus dissolving the boundaries between the groups, and extending the audience's knowledge of American glass art to diverse contemporary artists.

This exhibit has been guided largely by our Emeritus Director, J. Weldon Smith, who retired earlier this year. It was through his support that funding from the National Endowment for the Arts was obtained, and through his steady commitment to the community that this museum serves, that this exhibit came about. On behalf of the Board of Trustees, and the staff, I extend my thanks to Weldon.

MIRIAM DE URIARTE, Director

Defining Community: The First Generation of Native American Glass Artists

CAROLYN KASTNER

The Museum of Craft & Folk Art is proud to present the artwork of eighteen Native American artists and one of their non-Native teachers in *Fusing Traditions: Transformations in Glass by Native American Artists*. The goal of this exhibition and catalogue is to make visible to the world a movement powered by a group of artists whose innovative techniques and creative visions are shaping a new language of American art. Gathering the artwork of these artists allows us to compare their work and focus on the distinct way in which each person has incorporated his or her individual identity and cultural traditions into the ancient and shared medium of glass. In this exhibition and catalogue we refuse to rehearse the arguments about the distinctions between art and craft. Instead, we offer a series of essays about the history of glass and Native American art to help locate this important group of artists within the landscape of contemporary American art. Roslyn Tunis and Lloyd Herman present the cultural and artistic forces that power this movement. Tunis offers a visual history of the Native American cultural sources of the artwork. Herman's essay describes the studio glass movement in the Northwest. Artist Preston Singletary reflects on the artistic and cultural journey that brought him to the Pilchuck Glass School and his Tlingit heritage. Importantly, Kate Morris demonstrates the affinities between the Native American artists working in glass and those working in other media as they fight for critical and aesthetic response to their innovative works.

This exhibition investigates glass as a contested medium: seen as traditional when viewed from the European American view point, innovative when viewed from the Native American perspective. It is still a place of negotiation, where visual cultures fuse and sometimes clash. This first generation of Native American glass artists came to the medium one by one. They experimented with the properties of glass—its ability to assume any form, its translucence, its permanence—and one by one they brought something completely new to the formal language of glass. Preston Singletary saw the shape of a Tlingit hat in the bowl forms he was blowing—and began to carve Tlingit iconography into the inverted shapes to form Tlingit glass hats. Tony Jojola shaped vessels that evoke the pottery traditions of the Isleta Pueblo. Susan Point imagined the familiar Salish wooden spindle whorl transformed in glass. Though working in a new medium, these forms are rooted in the tradition and place of their Native cultures. Marcus Amerman reinvigorates the tradition of glass beads by reworking this old medium in complex and contradictory new forms. The artwork of this post-modern *Bricoleur*

is suspended between cultures, time, and media, which relocates beadwork in the twenty-first century. As these artists experiment, they bring fresh ideas to the ancient medium of glass and form a new language of Native traditions and American art.

The defining category of glass art sets these artists apart from the discourse of contemporary art and Native American art. The categories of glass and Native American art are a double bind in an art world still dominated by a hierarchy of Western media and culture. Yet, as Kate Morris reminds us in her essay, this community of glass artists shares the artistic and cultural concerns of the larger community of contemporary Native American artists just as surely as they work in the shared environment of other contemporary glass artists.

Glass is a fluid medium that by its nature can fuse and meld disparate ideas, colors, and forms. Furthermore, the collaborative nature of the hot glass process invigorates the art form as artists assist each other to bring personal visions to life. Cross-cultural collaboration enriches this process even further. The artists represented in this exhibition exemplify the power of an inclusive and supportive community, a celebrated tradition among Native peoples, who value relations and connections. They have a shared history and experience in their training and work at the Pilchuck Glass School. Just as they have assisted each other in realizing artistic creations in the studio, they directed the development of this exhibition by identifying and encouraging each other to participate.

The Pilchuck Glass School is pivotal in the development and identity of these artists as a movement. Most of the artists have studied at the school and worked together under the supervision of teachers such as Dale Chihuly and David Svenson. Preston Singletary and Tony Jojola met at Pilchuck in 1984 and later worked together at Benjamin Moore Glass Art in Seattle. They also collaborated on a Chihuly team that assisted Italian glass master Lino Tagliapietra. Singletary and Ed NoiseCat combined forces on a Blown Glass Mask project at Pilchuck Glass School. The project produced distinct mask forms even though they worked from a common model. NoiseCat carved the original mask from red cedar, from which he made a two-part bronze-hinged mold. Singletary then blew glass into the mold. Each artist's unique vision was inscribed on the finished forms.

Acting as a community, these artists gathered to raise a totem pole in commemoration of the Pilchuck Glass School's thirtieth anniversary. During the summer of 2001, they carved and painted a twenty-foot totem pole embellished with glass and neon components. This stunning achievement, which transformed both the traditions of wood carving and glass art, was raised in honor of founders Dale Chihuly, John Hauberg and Anne Gould Hauberg. It is also a monument to the vigor of this artistic movement. The totem pole project brought experienced Northwest Coast wood carvers to the Pilchuck Glass School to work with Native and non-Native glass artists. Influenced by that experience, wood carvers Joe David, Wayne Price, and John Hagen began to experiment with glass and neon components in their subsequent art. Conversely, Native and non-Native glass artists worked together to create and raise the totem pole.

This inclusive community can also be identified by how it has been excluded and neglected because of Western traditions of hierarchy of medium and culture. By bringing them together for *Fusing Traditions*, we present a vibrant and

growing group of artists distinguished by their contributions to the glass medium and their cultural traditions. We hope to break the critical silence on their achievements, after all the most mature of these artists have been working in glass for more than twenty years. Even though their efforts cannot be defined as a new movement, this exhibition brings together for the first time a group of artists overlooked by contemporary glass and Native American art exhibitions and surveys. During the past five years, several of the artists have been identified and included in Native American craft exhibitions such as *Head+Heart+Hand=Native American Craft Tradition in a Contemporary World*, organized by the Kentucky Art and Craft Gallery in 1998, or the currently traveling exhibition organized by the American Craft Museum, *Changing Hands: Art Without Reservation*. Some have been recognized for their individual achievements, as in Tony Jojola's retrospective, *Born of Fire*, at the Wheelwright Museum in 2000. Yet as a group the very communities who benefit from their vitality have ignored them. It is time their work was gathered in one place to allow comparisons of style and techniques and to demonstrate the vigor of their influence and the mastery of their chosen techniques. As artist Kay Walking Stick has argued this is not new to Native American artists, and it continues to be a problem. "Critical questions that would be raised in other venues simply are not considered in ethnic or gender-specific exhibitions. Not to receive serious critical review is a kind of disempowerment."[1]

Now, as a sign of this movement's vigor, a second generation of Native American artists working in glass is emerging under the tutelage of Tony Jojola in Taos, New Mexico, and at the Pilchuck Glass School, where Preston Singletary is encouraging Native students to experiment and expand their horizons. This exhibition includes the artwork of two young artists: Robert Tannahill (*Big Mouth*), who has broken with the functional and decorative origins of glass, and Brian Barber (*The Breath of Heaven, The Vault of Heaven*), whose cast glass figures are similarly enigmatic and authoritative. These artists are working in a cultural realm where the visible is not always legible to the uninitiated, yet even the culturally initiated will find these figures in glass startlingly new. Their artwork offers a glimpse of the powerful future of this movement.

The artwork presented in *Fusing Traditions* is alive with relationships between generations, individuals, and cultures. The power of cultural heritage is visually expressed in each work of art. Equally powerful is the community built in the process of creating this art. Expressing culture and community, these artists are shaping a new language of American art.

Carolyn Kastner is Curator of the Museum of Craft & Folk Art. She earned her Ph.D. in American Art from Stanford University in 1999.

1. Kay Walking Stick, "Native American Art in the Postmodern Era," *Art Journal* 51, 3 (Fall 1992), 15.

Ancient Echoes/Contemporary Voices

he Native American artists in *Fusing Traditions* are creating works of art that draw upon their rich heritage to forge a contemporary Indian aesthetic. Their work shows a clear continuity with the past in design and form and their choice of glass as a medium is a clear reflection of their contemporary sensibilities.

Many of the Native artists in this exhibition are actively involved in the lifeways and ceremonies of their respective nations. In addition, they have researched museum resources and extensive collections of their material culture. The stories, imagery, and forms from the past continue to inspire them.

The shapes and designs in their contemporary work, while clearly connected to the iconography and imagery of their cultural heritage, look startlingly original when transformed in the glass medium. These dramatic new works are artistic statements; works of art intended for exhibition and sale to galleries, museums and collectors, and not intended for ritual or ceremonial use. Yet their connection to the traditions of their ancestors conveys an enduring respect for, and a desire to preserve, their common history. In this manner too, these artists are transmitting a sense of their heritage both to their heirs as well as to the general public.

Long before the arrival of European explorers in the Americas, indigenous peoples were trading throughout the continent. Religious, social and artistic hybridity were visible consequences of these interactions. Colonists brought materials unknown on this continent, such as glass beads, buttons, silver, copper, and manufactured fabrics. In 1492, Columbus notes that he gave the women of San Salvador "necklaces of green beads." By the sixteenth century, tribes in the Northeast were using glass beads of European origin. And in the eighteenth century the Russians brought trade goods to Alaska and the Northwest Coast. Native peoples readily adopted and integrated these introduced materials into their life and culture.

In recent years, a group of talented Native American artists have selected glass as a medium for their work. With its long history, its mutability and potential for dynamic expression, glass provides creative opportunities found in no other medium. Unlike their predecessors, however, who learned their craft by apprenticeship within their own culture, these artists have chosen to study glass making at universities, art institutes and the Pilchuck Glass School with Dale Chihuly, David Svenson, and others. They have not only mastered this medium but have taken it to new dimensions, creating hybrid glass forms that blend European, American and Native traditions in dramatic and exciting ways.

Marcus Amerman's and Clarissa Hudson's works of wearable art synthesize indigenous and introduced ideas, materials and styles. Amerman's *Killer Necklace* of peyote-stitched beads and bear claws references objects of personal

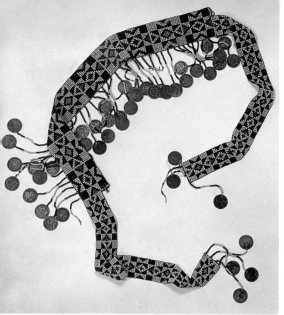

adornment worn by Native chiefs and leaders to signify status and power. Hudson's crystal bead *Egyptian/Tlingit Headdress* is inspired by headdresses formerly made of shell and bone worn by Tlingit, Aleut and Yupik women of rank, also beaded adornment worn by Russian women in the early period of Alaskan settlement.

The glass vessels of Tony Jojola and Ramson Lomatewama are inspired by the pottery and baskets of the Southwest, where they live. Jojola's *Evening Colors* echoes vessels of the pueblos in form, geometric and symbolic design. However, rather than the opaque, natural palette of clay and fiber, his translucent glass vessels are vividly colored, brilliantly reflecting light. Lomatewama's *Matrix of Life Becoming* references the historic pottery of the Hopi mesas in shape and cultural symbols.

C.S. Tarpley blends his mixed Native American and European heritage in his artworks. *Doumbeque*, a drum on which he actually performs, features a Moorish motif. He uses a complex electroforming technique, which fuses metal and glass to accent his multicultural designs. Tarpley says of his work:

> "What I seek to demonstrate is that many of the motifs that are commonly referred to as Greco–Roman or Indo–European in our Western thought are, in fact, truly universal and have been independently developed by other cultures separated by vast oceans and thousands of years."

Conrad House's *Lightning Prayer Sticks Protected by Turquoise Mountain Lions* captures the sense of power of ritual prayer sticks sometimes used by singers, healers, or shamans to bring about rain, success in hunting, or healing. His artwork is an unusual juxtaposition of carved glass rods, ceramic fetishes, feathers and shell.

Several artists in this exhibition are from the Pacific Northwest and Alaska, where Raven and the Moon are recurring images and the focus of many legends. Preston Singletary, despite his urban upbringing, has a deep understanding and reverence for his Native heritage. He incorporates Tlingit forms and symbolism in his evocative works. *Raven Steals the Moon* is a dynamic work that pays homage to this important figure. It is Raven who brings light to the world by releasing the sun, moon, and stars from a box in which they were hidden.

Like Singletary, John Hagen and Marvin Oliver visualize the moon as a glowing orb. Hagen integrates glass and neon into the subtly carved surface of his house shaped sculpture *Moonlit*. The lunar image in the center is reminiscent of clan crests that were

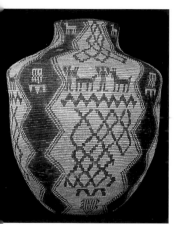

Fig. 1. (top)
Beaded Band with U.S. Dimes, Ute, Great Basin.
Earliest coin 1853, latest 1884, most common 1876, 1877. 38" long. Collected by William A. Owens, owned by Karen Bruhns.

Fig. 2. (above)
Large Coiled Storage Basket, Western Apache, Arizona, pre–1901.
Collected by Phoebe A. Hearst 1903. Courtesy Phoebe A. Hearst Museum of Anthropology, University of California, Berkeley. Cat. #2-2

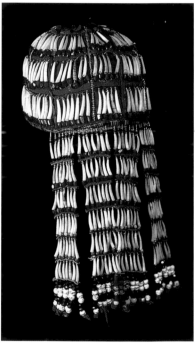

Fig. 3. (above)
Dentalium Shell Headdress, Lukaax. ádi, Tlingit, mid to late 19th century.
Originally owned by Jiyal.áx̱ch, wife of Berner's Bay Jim, a shaman. Courtesy Alaska State Museum, Juneau. cat. # ASM 11-B-82.

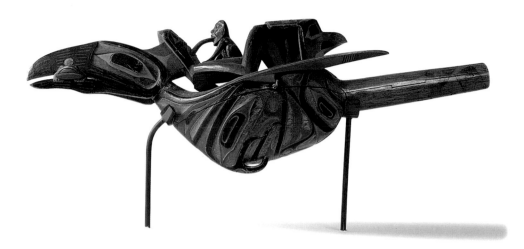

Fig. 4 (left)
Wood Raven Rattle, Tlingit 19th c.
Estate of Ellinor C. Davidson.
Courtesy Phoebe A. Hearst
Museum of Anthropology, University
of California, Berkeley.
cat. # 2-19094

Fig. 5 (below)
Wood War Helmet, Tlingit.
Estate of Ellinor C. Davidson.
Courtesy Phoebe A. Hearst
Museum of Anthropology,
University of California, Berkeley.
cat. # 2-19081

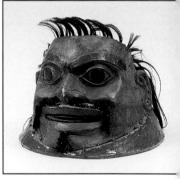

carved and painted on the front of Tribal Community Houses. Marvin Oliver's *Facing You* is a mask-like moon image made of dichroic glass. This type of glass manipulates light and reflects complementary colors from its surface encouraging viewing from many angles. Oliver says: "My works are formulated by merging the spirit of the past traditions with those of the present to create new horizons for the future."

Human, animal, and supernatural imagery are also part of the lexicon of Northwest and Alaskan iconography. Ed NoiseCat's anthropomorphic sculpture, *Baby Frog Vase,* features abstract and figurative frog designs on its surface. Frogs are revered because of their ability to live on both land and water and are considered to be spirit helpers to shamans.

Wayne Price is best known for his carving of wood totem poles. He now integrates glass and neon into his carvings, as in *Spirit Bear Vision.* This work that blends old and new captures the essence of this animal's spiritual nature with glass inlaid eyes and teeth that give the impression of an ethereal presence.

Susan Point became intrigued with the traditional Salish wood spindle whorl used to spin wool from sheep and mountain goats. These were often elaborately carved with complex imagery. Point's *Mythical Bird* is a carved and slumped glass disk inspired by these old wooden whorls. The dramatically enlarged spindle whorl takes on a new presence as contemporary sculpture.

Shaun Peterson's glass work also echoes those old spindle whorls in design and motif, as in his *Defining Wolf.* Wolf is a symbol of power in Salish culture and is the artist's personal *tananhous,* or spirit guardian, which he acquired as part of a coming of age ceremony. Wolf is also a major figure in Nuu-chah-nulth culture and ritual. Artist Joe David, who is known for his carvings of wood masks, has created a powerful opaque cast glass skull entitled *Spirit Wolf.* David honors this potent spirit with cedar bark, feathers, and the gift of tobacco.

Larry Ahvakana is from Northern Alaska and that dramatic environment influences his work. *Landscape at Icy Cape* is a lyric painting in glass; the iridescent colors and flying rods call forth the frigid and barren, but beautiful, landscape of the Arctic.

Fig. 6 (above)
Cedar Spindle Whorl, Coast Salish.
Gift of Frederick Beecher,
Courtesy Museum of Anthropology,
University of British Columbia,
Vancouver.
cat. #A4323
Photo: Bill McLennan

Fig. 7. (right)
**Men's House/Kashim Model,
Eskimo, Bering Sea, pre–1898.
Donated by Alaska Commercial
Company. Courtesy Phoebe A.
Hearst Museum of Anthropology,
University of California, Berkeley.
cat. # 2-4571**

Fig. 8. (below)
**False Face Corn Husk Mask,
Iroquois-Seneca, Cattaraugus
Reservation.
Collected by M.R. Harrington 1907,
Donated by Phoebe A. Hearst.
Courtesy Phoebe A. Hearst
Museum of Anthropology,
University of California, Berkeley.
cat. # 2-9151**

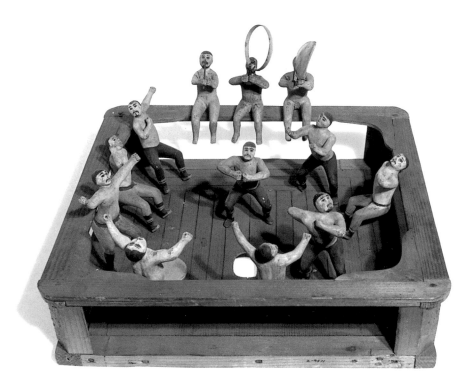

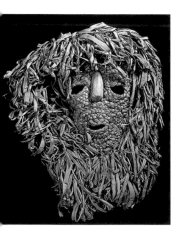

Brian Barber, Michael Carius, and Robert Tannahill are part of the second generation of Native glass artists. While recently trained, each artist reaches back into his family history for the subject of his artwork. Barber's *Breath of Heaven, Vault of Heaven* is based on his childhood memory of his grandfather, a man proud of who he was and of his culture. The work also refers to an annual planting ceremony, when Pawnee would paint their faces and dance around the fire. The painted line down the nose represents the Breath of Heaven. The painted arc on the forehead represents the Vault of Heaven. Carius' *Emperor Goose Clan Drummer* depicts the Eskimo tradition of transmitting history, stories and moral lessons through music, song and dance. A member of the Emperor Goose Clan, Carius consciously intends through his work to honor and preserve the way in which this information was transmitted in his culture. Tannahill's *Big Mouth* from the *False Face Series* evokes old Iroquois wood masks carved from the live tree and used in special ceremonies. Their features were often distorted to represent supernatural beings both revered and feared.

David Svenson has nurtured many of the artists in this exhibition and actively participated in their development as masters of the glass art. He, in turn, has been influenced by them. Svenson's wood and neon sculpture, *Touched by the Better Angels of Our Nature* is related to the original Lincoln totem pole, carved in the 1860s by Native Alaskan artists to honor the President. The title is part of a quote from Lincoln's Second Gettysburg address and refers to his act of freeing the slaves. The neon figures, surrounding Lincoln's head, are Svenson's version of angels. Svenson illuminates his glass with

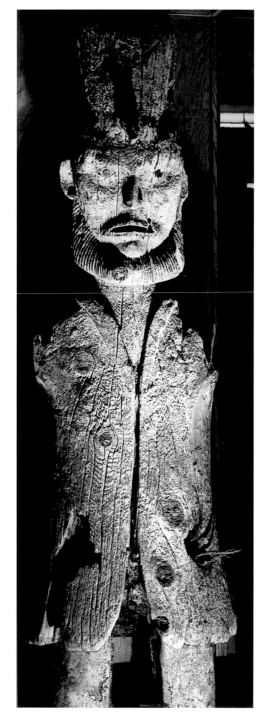

neon, which he calls "a bottled phenomenon of nature, the closest thing man can come to creating Northern Lights."

From its origins in antiquity, glass has been used for purposes both utilitarian and ornamental, in ways both traditional and exploratory. Glass artifacts have revealed to us a glimpse into many cultures long past. The exhibition *Fusing Traditions: Transformations in Glass by Native American Artists* features talented Native artists who have chosen the medium of glass to create art as well as to celebrate their heritage and preserve the memory of their traditions. Thus, this ancient material, with its unique properties, has once again become a medium through which the artists of the present communicate to the future.

Roslyn Tunis is an independent curator. She has an MA in Art History and Anthropology and thirty years of museum and gallery experience in New York and California. Throughout her career she has focused on art and culture of the indigenous Peoples of North America as well as fine crafts.

Fig. 9 (left)
The Lincoln figure from the Raven totem pole from the Tongass Tlingit; Taantakwaan Tlingit, Tongass village, mid 1800s.
Courtesy Alaska State Museum, Juneau. cat.# ASM-B-833

From the Fire Pit of the Canoe People

hen I first came in contact with glass, I was 15 years old. Dante Marioni had moved to Seattle from California to live with his father, Paul Marioni. We became fast friends in high school, and as it turned out Dante lived a few blocks from the house I grew up in. Paul was active in the Pilchuck Glass School in Stanwood, Washington, and worked with many different glass-making techniques. In the year after high school, Dante was already working in a production factory. I got a call and was asked if I wanted to work as a night watchman for the studio, cleaning the shop and filling up the furnaces with glass batch.

This appealed to me very much, and since I already knew some of the workers in the studio through my friendship with Dante, I was quickly moved to the day shift, where I mixed chemicals for the glass. Soon after, I started on a production team making Christmas balls and paperweights. This training gave me confidence in handling hot glass, and at first I looked at it as a job that would help support my music habit, which was my first career goal.

I began working with Benjamin Moore in 1984, after two years of factory work. In that studio I worked with artists, and helped execute pieces for designers and architects. I was working with some of the best glass blowers in the country. I watched and observed and learned from everyone. It was a fortunate thing to be able to learn through practical experience.

The first things I made and called my own were heavily influenced by the kinds of classical European vases and table objects that I had assisted others in making. One of the first Indian artists I met was Tony Jojola. He encouraged me to research my family background and make pieces that related to my cultural heritage. In 1987, I made my first attempts at applying Northwest coast imagery to the glass. That was the same summer I met David Svenson, who had lived in Haines, Alaska. He taught me about Northwest Coast wood carving and culture. He also encouraged me to learn more about these designs, which would eventually become instrumental in conceptualizing the Pilchuck totem.

After a few years, I decided to dedicate myself to developing the process of integrating Northwest Coast designs in glass. I had worked a lot with Tony Jojola through Benjamin's studio, and I watched how he approached his work from a cultural perspective. My family grew up outside of the traditional Tlingit region, so it was hard to know where to begin. I started approaching other Native artists and galleries to show them my work and get input about it. I received a lot of encouragement about what I was doing, and it has led to some great friendships and working relationships.

My family has always known where we came from. My great grandmother, Susie Johnson Bartlett Gubatayo, moved to Seattle in the 40s. She told us about the way it used to be, and all the hardships our people had to overcome. That we came from "high class people." Our crest symbol and stories were written down by my great uncle. My grandmother Lillian Abada told me in one of our last conversations that if anyone were to look at her life's work they would have to look at her grandchildren. This has taken on a new meaning for me as I have moved forward with my work and started my own family. Looking back at the path I have taken, I feel a tremendous sense of purpose.

Collaborations with glass work have developed naturally and I see this as a way to learn about Indian culture while sharing my knowledge of glass with others. I feel the Native glass "movement" is bringing a new dimension to Indian art. There is an aesthetic which can be identified that is a unique interpretation of Native artists' concepts in the medium of glass. The successful piece uses the translucent qualities of glass and goes beyond to another level. In my mind, the question should be "Why glass?" That single question provokes the artist to search for new possibilities. There are a lot of different ways of working with glass, and it is not easy to achieve great results in the beginning.

In the summer of 2000, I was able to work with Joe David, the Nuu-chah-nulth master carver, at Pilchuck. He was the artist in residence at the school, and had free reign over all the facilities. My job was to assist him for three weeks. During that time he was compelled to build a ceremonial sweat lodge on the campus. Those who attended the session were invited to partake in the ceremonies. It was explained that it was a purification ritual, and that we would suffer a bit and sacrifice during the event. Those interested approached Joe and he, after telling them what they needed to know and looking into their eyes, would let them know if they were ready to participate. Since I had never done a sweat before, I was a little apprehensive. As the day approached, I told Joe, "Look me in the eyes and tell me if you think I am ready to do this." He said, "Let me put it this way . . . you'd better be!" Of course he was only joking, but moreover, he was compelling.

In eleven days, we did four sweats together. I assisted in all the ceremonies, which lasted four to five hours each. At the end of the session he adopted me in a public ceremony and shared his name with me. This was the highest honor he could have given me. And it added to the responsibilities of how I conduct myself as an individual and an artist within the Native community and beyond. I can't say it was a religious experience, but it did give me insight to a spiritual force that I had not connected with before that time.

At this point the Pilchuck totem pole had already been approved, and it was to be completed in the summer of 2001. It was a project that had been initiated by David Svenson in 1995. On a trip we made to Haines, Alaska in the spring of 2000, we discussed the idea of the pole. It would be dedicated to the founders of the Pilchuck Glass School: John Hauberg, Anne Gould Hauberg and Dale Chihuly. David had been on the school's faculty a couple of times, but my close proximity and connection to the school put me in a perfect position to drive the project. I proposed the idea to the president of Pilchuck's board, and it was instantly supported.

John Hauberg had already been recognized by a Tlingit clan in Angoon, Alaska for repatriating a ceremonial dagger, and had been given the Tlingit name Gooch-ki-yeats. This was another reason we thought it was appropriate to

make a totem pole for the school. The pole would be symbolic of John's passion for Northwest Coast art, glass and wood, and would pay tribute to his legacy, the Pilchuck Glass School. It was decided that we would form a class to finish the pole during the summer of 2001. Among the ten students in the class, six were Native Americans.

Other artists who were close to Hauberg were selected to carve separate pieces which would be cast in glass and incorporated into the pole. The carving team, who began their work in Alaska, brought the pole to the campus in the beginning of August, and continued to put the finishing touches on it. As a class, we worked together to create the glass and neon elements for the pole, and fragments for the decorative base. Local tribes were invited to visit the school and participate in various welcoming ceremonies. The entire school participated in the painting and installation of the pole on August 28th, 2001. John Hauberg was not in attendance due to open heart surgery and, sadly, died in April, 2002 from complications after a heart attack. John did, however, get to see the pole in September after the installation.

I am a product of the Pilchuck Glass School. First, I became an apprentice and a member of the glass community. But my art education can be attributed to Pilchuck. In a roundabout way, the school brought me closer to my cultural identity. By bringing artists and fresh ideas to the school, Pilchuck paves the way for new techniques and concepts, and energizes the students and faculty alike. One leaves the school full of inspiration and creativity, often for years to come.

I see this exhibition as a positive force for the Native community. It is an opportunity to look at what has been done, and realize the potential for what can come. My hope is that the numbers of Native artists working in glass will grow. Glass-making requires working together as a team, and learning to work together can produce better results over time. A piece that survives the fires or grinding and does not break can be looked at as a gift which contains grace and fragility all at once. The balance of cultural knowledge and the technology of glass can be very compelling, as we can see in this show.

Preston Singletary is an artist working in glass and served as Curatorial Consultant to the exhibition *Fusing Traditions.*

'Anxious Objects': Glass in the Context of Contemporary Native American Art

K A T E M O R R I S

here's a revolution happening on the pueblo," declared Tony Jojola, heralding the establishment of the Hilltop Glass Arts Program at Taos Pueblo in 1999.[1] Indeed, the past few years have witnessed a remarkable surge in interest in the Native American studio glass movement. In concert with the installation of the hot shop at Taos, the raising of a totem pole at Pilchuck Glass School, and the mounting of a major retrospective of Jojola's glass works at the Wheelwright Museum in Santa Fe, *Fusing Traditions* celebrates the achievement of artists of Native American descent who have turned to glass as a medium for creative expression.

For many of us who have organized, contributed to, or simply been fortunate to encounter this exhibition, our sense of excitement at discovering these dynamic and inspiring works of art is perhaps enhanced by our sense that we are witnessing (or in the case of these 19 artists, participating in) the emergence of a fundamentally new genre. Sharing this enthusiasm, Lloyd Kiva New has suggested that the incorporation of studio glass may constitute the "most significant Native American art movement since beadworking in the 1700s and metal-smithing and the use of silver in the 1850s."[2] Though our excitement is justified, it is important to note that while Native American works in glass are emerging into the light of public recognition and critical acceptance, studio glass is not, strictly speaking, a "new" medium for Native American artists.

Perhaps no one understands this better than Jojola, for it was he who walked into the small hot shop near the Old Barn on the campus of the Institute of American Indian Arts in Santa Fe, and taught himself to blow glass. The year was 1975.[3] By 1977, glass arts were an established part of the IAIA curriculum, with courses in the "basic techniques of free-blown glass—including free-forms, mold–forms, form additions, color theory, and design theory of glass" offered by sculpture instructor Carl Ponca.[4] While students at IAIA were learning to work with glass, and Jojola's pieces were garnering a slew of awards in the "miscellaneous contemporary" category of Santa Fe's annual Indian Markets from 1978 forward, for all intents and purposes, Native American glass arts languished in critical obscurity for nearly a quarter of a century, only to emerge in such spectacular fashion today.

Why has this recognition been so long in coming? One answer to this question may be located in the history of critical reaction to the studio glass movement itself. Since the earliest days of experimentation with studio glass in the

1960s, artists working in glass have waged an ongoing battle with the mainstream art establishments over the status of this medium, specifically, over whether it is appropriate to speak of studio glass as a "fine art." It seems that glass, by virtue of its medium alone, has found itself repeatedly relegated to the realm of "crafts," and has thus been denied serious critical attention, despite its obvious affinities with the major formal movements and ideological concerns of mainstream modernism. So persistent is this exclusionary bias that Donald Kuspit, in the introduction to a 1998 volume on Dale Chihuly, credits the artist with "obliterating the difference between craft and art," while simultaneously suggesting that works in glass may yet be considered "anxious objects"—works that "persist without a secure identity."[5]

What then, are the roots of this bias? In a recent article on the history of the studio glass movement, Bonita Fike suggested that works in glass were regarded with suspicion by the mainstream art establishments because the movement emerged during an era dominated by abstraction, minimalism, and conceptualism[6]—artistic movements that tended to devalue or de-emphasize the object, and to privilege the intellectual process over the physical act of fabrication.[7] Glass was celebrated for its unique qualities, including its ability to focus, diffuse, refract, or otherwise transmit light, and for its spiritual, even redemptive connotations.[8] Nevertheless, studio glass works were suspected of being limited in their ability to express ideas, to have intellectual content, and thus to contribute to the dialogue of mainstream artistic discourses beyond those of pure formalism. As Fike noted, these problems intensified in the 1980s and 1990s, decades that were characterized by an increased interest in personal and political expression in the arts. In the past several years, scholars of the studio glass movement have made a concerted effort to document the ways in which glass artists and their works have in fact been influenced by, and contributed to, these mainstream artistic discourses.

As we turn our attention to the works in this exhibition, we might pause to consider whether works in glass by Native American artists are more or less likely to be subjected to the kinds of biases that have plagued the studio glass movement. Given the inclusive, rather than exclusive nature of the "canon" of Native American arts—one that embraces media ranging from textiles, ceramics, and painting, to photography, installation, and performance art—it may be that Native American artists and their audiences are better prepared to embrace this genre, having dispensed with the "arts vs. crafts" debate some time ago. If there is a categorical bias that occasionally operates within the Native American arts world, and that might influence the viewers' perception of the works in this exhibition, it is one that seeks to distinguish not between "arts" and "crafts" but between "traditional" and "non-traditional" arts.

Since the very earliest exhibitions of Native American art in the United States, the issue of what might be considered "traditional" has been of concern to curators and, presumably, to the museum-going public. Anticipating the objections of some viewers to the "non-traditional" works included in the 1941 exhibition of Indian Art at New York's Museum of Modern Art, Douglas and D'Harnoncourt made a case for the liberal view on this issue: "Invention or adoption of new forms does not necessarily mean repudiation of tradition but is often a source of its enrichment," they argued. "To rob a people of tradition is to rob it of inborn strength and identity. To rob a people of the opportunity to grow through invention or through acquisition of values from other races is to rob it of its future."[9] This sentiment was repeated

in 1968, when Lloyd Kiva New, spelling out the philosophy underlying the curriculum of the recently opened Institute of American Indian Arts (where the Native American studio glass movement was soon to emerge in its most nascent form), advanced the argument in these terms:

> The Institute does not believe it possible for anyone to live realistically in outmoded tradition, but does believe it to be the business of the artist especially to create new and worthy actions leading to new traditions. The Institute assumes that the future of Indian art lies in the Indian's ability to evolve, adjust, and adapt to the demands of the present, and not on the ability to remanipulate the past.[10]

Despite these repeated interventions, Native American artists continue to find themselves and their work defined with respect to certain essentialist categories. According to Tuscarora artist, educator, and critic Rick Hill, innovative artists, especially those working in new media, "have been drawn into a defensive posture, forced to defend their art to patrons, curators, and collectors."[11]

Hill's characterization may ring familiar to some of the artists whose works are included in *Fusing Traditions*. As Marcus Amerman declared in his artist's statement for this exhibition: "Art is War . . . I see every medium of creativity I use as a weapon that I wield in battle." While alluding perhaps to the situation that Hill describes—in which the question of who or what defines Native American art eclipses more appropriate critical and aesthetic responses to innovative works – Amerman's statement simultaneously evokes the most proactive and positive aspects of artistic expression. In this respect, Amerman's sentiment is shared by many Native American artists, such as Seneca-Tuscarora painter George Longfish and Cheyenne-Arapaho conceptual artist Hachivi Edgar Heap of Birds, each of whom has written eloquently on the subject of the warrior tradition as a vital force in contemporary art.[12]

That this kind of affinity between a Native American artist working in glass and those working in other media should be illuminated by *Fusing Traditions*, attests to what is potentially the most significant contribution of this exhibition. By bringing these disparate works together for the first time, *Fusing Traditions* seeks to answer the kind of question that Walla Walla painter James Lavadour posed of his own work: "Is there a way to rub two sticks together and create a certain kind of friction and that friction creates light? . . . [T]o create a work of art that is truly a shining, transcendental thing, that is sustaining, that gives energy[?]"[13]

Kate Morris teaches art history at the California College of Arts and Crafts in Oakland, California. She earned her Ph.D. from Columbia University in 2001, and is currently working on a book based on her dissertation, entitled, *Picturing Sovereignty: Land and Identity in Contemporary Native American Art.*

1. Quoted in Keith Raether, "Through a Glass Brightly: New Tradition of Transparent Artwork Dawns at Taos Pueblo," *Native Peoples* 12, 3 (Spring 1999), 27.

2. Ibid.

3. The glass shop at the Institute of American Indian Arts was installed in 1974 by Dale Chihuly. Chihuly's home institution, the Rhode Island School of Design, was at that time providing IAIA students with associate college credits. Chihuly stayed long enough to involve IAIA students in "Glass Pour," a work in which glass was poured directly onto the ground outside of Santa Fe. See Dale Chihuly, *Chihuly Projects* (Seattle: Portland Press, 2000).

4. *Institute of American Indian Arts Course Catalog, 1977-1978*. Published by the United States Department of the Interior, 1977.

5. Kuspit wrote: "It is an old bugaboo: the difference between craft and art, art's assumed superiority to craft, the craftperson's secondary position compared to the artist's primacy. For all the craftperson's efforts to make objects indisputable as art, whether good or bad, he or she supposedly never quite succeeds: by definition craft is not art." Donald Kuspit, ed., *Chihuly* (New York: Harry N. Abrams, Inc. 1998), 30. In speaking of "anxious objects," Kuspit is reviving a term coined by Harold Rosenberg in *The Anxious Object: Art Today and Its Audience* (New York: Horizon Press, 1964). Ibid., 47, fn 5.

6. Bonita Fike, "The Art-Historical Context of Contemporary Glass," in *A Passion for Glass: The Aviva and Jack A. Robinson Studio Glass Collection* (Detroit: Detroit Institute of Arts, 1998).

7. To my mind, we might also wonder whether the very nature of studio glass production—as an invariably collaborative project—leads some critics to suppose that these objects are not by definition products of an individual artistic vision, and thus do not meet the criteria of the persistent myth of creative genius.

8. For discussion of early twentieth century notions of the spiritual properties of glass, see Ron Glowen, "Looking for Meaning: Glass in Twentieth Century Art," in *Glass: Material in the Service of Meaning* (Seattle: University of Washington Press, 1991).

9. Frederic Douglas and Rene D'Harnoncourt, *Indian Art of the United States* (New York: Museum of Modern Art, 1941), 10.

10. Lloyd Kiva New, "Using Cultural Difference as a Basis for Creative Expression" (1968); cited in Joy Gritton, *The Institute of American Indian Arts: Modernism and U.S. Indian Policy* (Albuquerque: University of New Mexico Press, 2000), 118-119.

11. Richard Hill, Sr. "The Battle Over Tradition," *Indian Artist* 1, 1 (Spring 1995), 93.

12. See for example, Longfish's artist's statement in *Indigena: Contemporary Native Perspectives in Canadian Art*, in which he avows that "the greatest lesson we can learn is that we can bring our spirituality and warrior information from the past and use it in the present and see that it still works." *Indigena: Contemporary Native Perspectives in Canadian Art*, eds. Gerald McMaster and Lee-Ann Martin (New York: STBA Ltd., 1992), 163. See also, Hachivi Edgar Heap of Birds, "My Past, My People," in *Sharp Rocks*; reprinted in *Blasted Allegories*, ed. Brian Walis (New York: New Museum of Contemporary Art, 1987), 171.

13. James Lavadour, quoted in Vicki Halper, *James Lavadour: Landscapes* (Seattle: University of Washington Press, 2001), 23.

Nurtured in the Northwest: Contemporary American Glass Art

LLOYD E. HERMAN

lass is one of our most commonplace materials—we look through it, drink from it, and clad buildings with it. It corrects our eyesight and protects us from weather at home and in our cars. Glass bottles and jars were once expendable; now we recycle them. Yet, for 4500 years glass has been made into beautiful things, and today it is the newest—literally hottest—material for art. And the largest concentration of glass artists in the world is in the Puget Sound region stretching from Portland, Oregon, to Vancouver, B.C. When Venice, Italy, is widely considered to be the historical center for glass, why is the Pacific Northwest now the world center for glass art? Simply because the Pilchuck Glass School there has become the most important international center for glass education, making the region a magnet for glass artists.

In travels and in books we've all seen stained glass windows made in the Middle Ages that depict Bible stories, cut crystal chandeliers, and Bohemian goblets for the tables of kings. But until 1962 it was impossible for an individual artist to blow glass in the studio. The luxurious art glass that brought fame to Louis Comfort Tiffany a century ago, and to his rival for iridescent glass, Frederick Carder, founder of the Steuben Glass Works in New York State, was made by a team of skilled glassblowers in a factory.

Certainly glass was being used for art in the first half of the 20th century, but artists could only make stained glass windows composed of pieces of colored flat glass, or they could fuse pieces of glass together in a small kiln, or, using a small gas torch, make glass thread sailing ships, tiny animals and other souvenirs using a technique known as lampworking. But glass could not be blown except in a factory situation with furnaces to melt glass to the consistency of honey, and by technicians who could hold and blow the heavy weight of a blob—or gather—of it on the end of a blowpipe. This took several sturdy men, working as a team.

In 1962, a Wisconsin potter, Harvey Littleton, and a consulting glass engineer from one of the Ohio glass factories, Dominick Labino, led a workshop at the Toledo Museum of Art in Ohio to experiment with a furnace small enough for an artist to use. Labino brought glass marbles that could be melted at a lower temperature than industrial glass. Within a decade, nearly one hundred hot glass programs had sprung up all over the country in art schools and universities. The contemporary studio glass movement was born!

Among the first students at Littleton's fledgling glass program at the University of Wisconsin was Dale Chihuly, a native of Tacoma, Washington. Chihuly helped set up a glass program at the Rhode Island School of Design and was teaching there in 1970 when he hatched the idea for an experimental summer camp at which students from several schools could come together and blow glass.

Together with the California College of Arts and Crafts, Chihuly applied for, and received, a grant of $2,000 from the Union of Independent Colleges of art for the summer experiment. They didn't know yet just where the camp would take place, so the poster simply said they would convene at Dale's mom's house in Tacoma!

Seattle art patrons John and Anne Gould Hauberg saved the day when they agreed to let Chihuly's group use the tree farm they owned in the foothills of the Cascade mountains near Stanwood, Washington. It was mostly stumps and second-growth forest, but had a majestic view of Puget Sound.

First priority for the 16 students that summer, and those who served as faculty, was building shelters and two glass furnaces. They scrounged dumps in nearby towns daily, and got access to government surplus through one faculty member's connections at the University of Washington.

Chihuly lived in his van the first summer, but others dug holes to sleep in, or made temporary shelters, and everybody cooked their own meals. It was really more of a hippie camp than an organized school, and that first summer faculty and students worked together in nearly constant rain. Within two weeks the first glass was blown. The only colors available were clear, purple, blue, brown and green—made with colored glass marbles or chemicals.

1972, the second year, brought the first foreign faculty member, Erwin Eisch from Germany—the first of what was to be the international influence on American glass art, and on glass education in this country. Work by faculty members in the early 1970s was both experimental and sophisticated—aware of pop art and funk ceramics.

The basic form in blown glass is the bubble, but a variety of vessels can be made from such a simple-seeming idea. Blown vessels can be made from glass of any color and manipulated into various shapes. Additional colors can be fused to the surface, or designs engraved or sandblasted into the glass. Several shapes made from bubbles can be joined together to create new forms of infinite variety, large and small. Most artists working in glass exploit the clarity and sparkle of translucent colored glass; a few obscure these prominent elements to create illusory space and density.

Over the years, innovative American artists found ways to make bowls and other vessels without blowing them. Toots Zynsky's boyfriend invented equipment that would extrude glass threads like a pasta-maker, which she would layer over an inverted bowl with a pizza paddle to form her opulent vessels. Benjamin Moore, head of education at Pilchuck for 13 years, adopted Venetian latticino techniques that had been guarded for centuries until taught at Pilchuck. An early Pilchuck student once surmised that the predominant style emanating from the school might be described as "West Coast/Italian" because Venetian glassmaking secrets guarded for centuries were popularized at Pilchuck.

Pilchuck's flat glass shop was developed initially for traditional stained glass: the making of pictures in colored glass. Faculty members introduced contemporary ideas using age-old techniques of enameling onto the flat glass surface,

and taught Pilchuck students how glass can manipulate light in architecture. Others from stained glass backgrounds developed a mixed-medium approach to their art, incorporating disparate objects and materials.

As Pilchuck and other glass education programs developed, glass art in America became more technically accomplished, artistically sophisticated and diverse, reflecting both the influence of faculty and students from other countries and the American exploration of technology. For example, compositions made of flat glass sheets could be cut, fused and polished—and sometimes painted and embellished with found objects.

Casting also entered the glassworking vocabulary of American artists, where molten glass is poured directly into molds, chunks of glass are melted to liquid inside the mold when the mold containing them is heated to melting, or ground glass is heated in the mold to the point of fusing into a solid. This last process is called pâte de verre. Lampwork or flamework, the technique of melting glass rods over an open flame that is familiar at amusement parks and fairs, has also gained prominence for making sculptural compositions, further diversifying glass art today.

Because of the prominence of Northwest Coast Native art in the region, it is not surprising that Indian artists have also turned to glass for cultural and personal expression. Marvin Oliver and Preston Singletary are among the Native artists who have translated traditional forms and motifs into glass. Singletary especially has adopted unique formline designs that may be used legitimately only by artists associated with Northwest Native cultures.

Though Europe provides the roots of contemporary American glass, both technically and stylistically, innovation truly characterizes American art, including glass. And, like America itself, diversity is the keyword!

Lloyd Herman is an independent curator and writer on contemporary American craft topics. He was the founding Director of the national craft museum of the United States, the Smithsonian Institution's Renwick Gallery, 1971-86, and Director of the Cartwright Gallery/Canadian Craft Museum, 1988-91.

L A R R Y A H V A K A N A

Landscape at Icy Cape
Fused glass, Kugler glass
18 x 18 inches
1988

Collection of Sue Ericsen

MARCUS AMERMAN

Killer Necklace
Necklace with peyote-stitched beads and bear claws,
cut beads, leather-covered wood beads, bear claws, with earrings
14 x 2 x 2 inches
2002

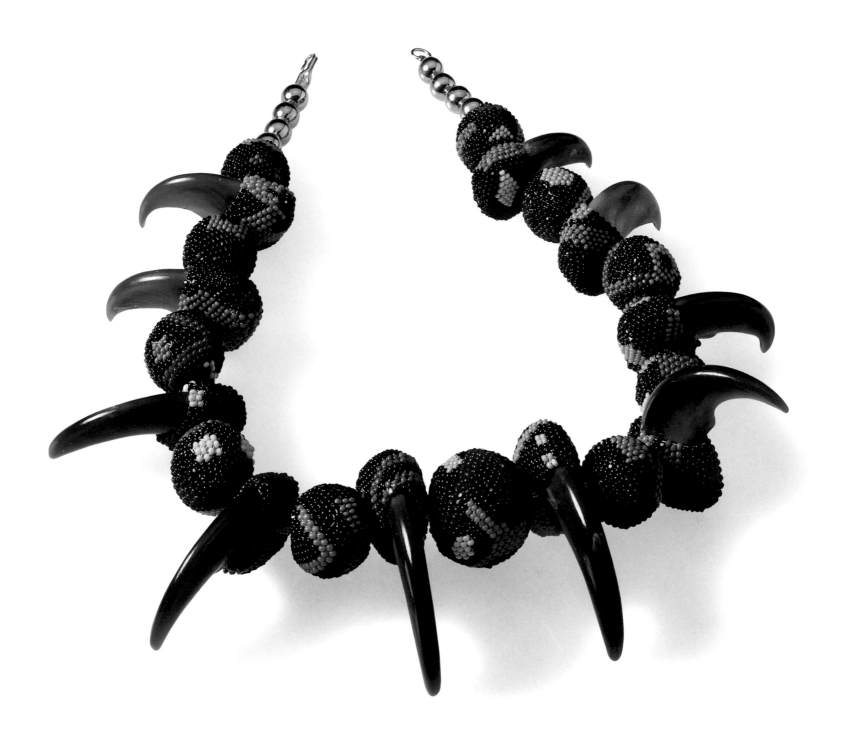

B R I A N B A R B E R

The Breath of Heaven, The Vault of Heaven
Sandcast glass, oil paint
8 $^1/_2$ x 6 $^1/_2$ x 6 $^1/_2$ inches
2000

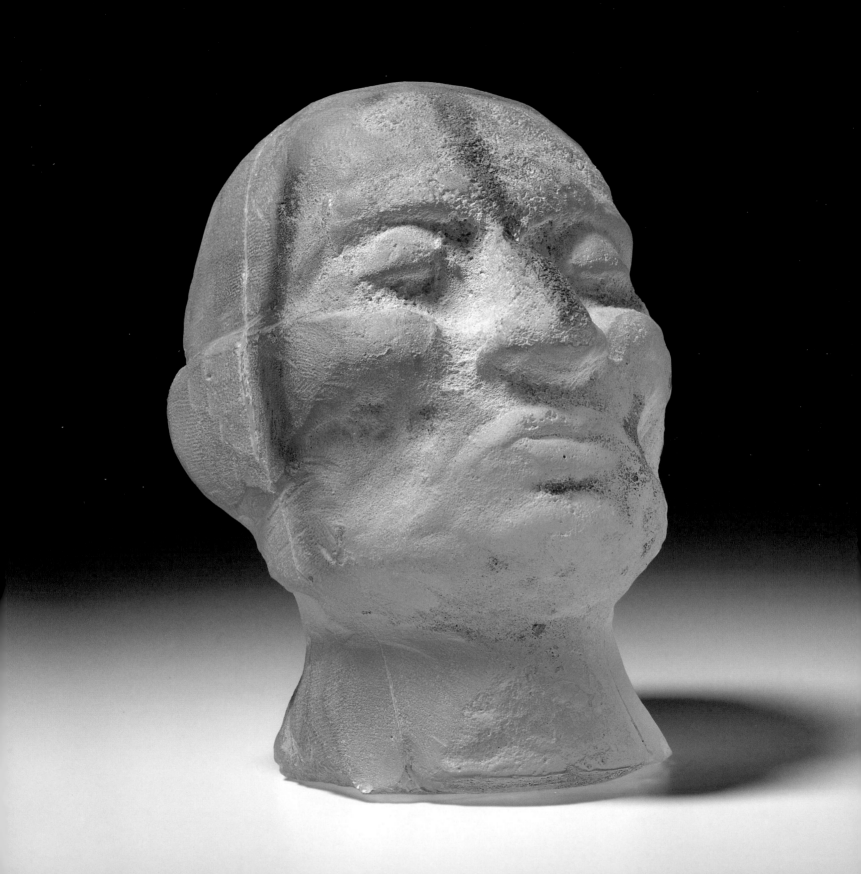

MICHAEL CARIUS

Emperor Goose Clan Drummer
Hot sculpted glass, forged steel
12 x 7 x 6 inches
1999

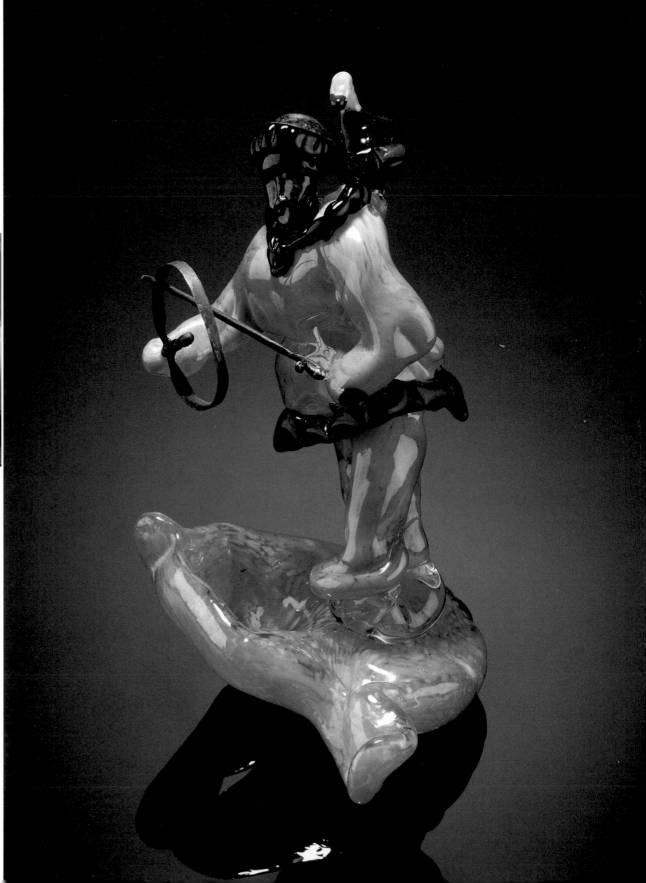

JOE DAVID

Spirit Wolf
Cast glass, cedar bark, horsehair, painted feathers, cotton,
tobacco, string
10 x 13 x 7 inches
2001

Collection of John and Joyce Price

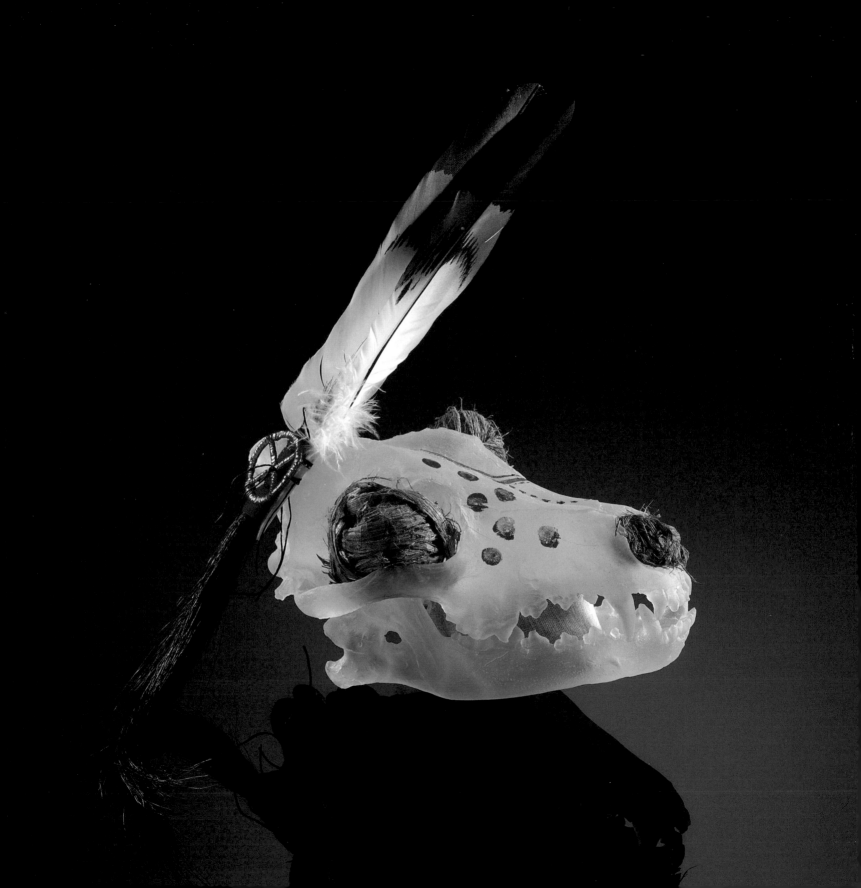

JOHN HAGEN

Moonlit
Cast glass, carved red cedar with neon lighting
21$^{1}/_{4}$ x 19 x 7$^{3}/_{4}$ inches
2002

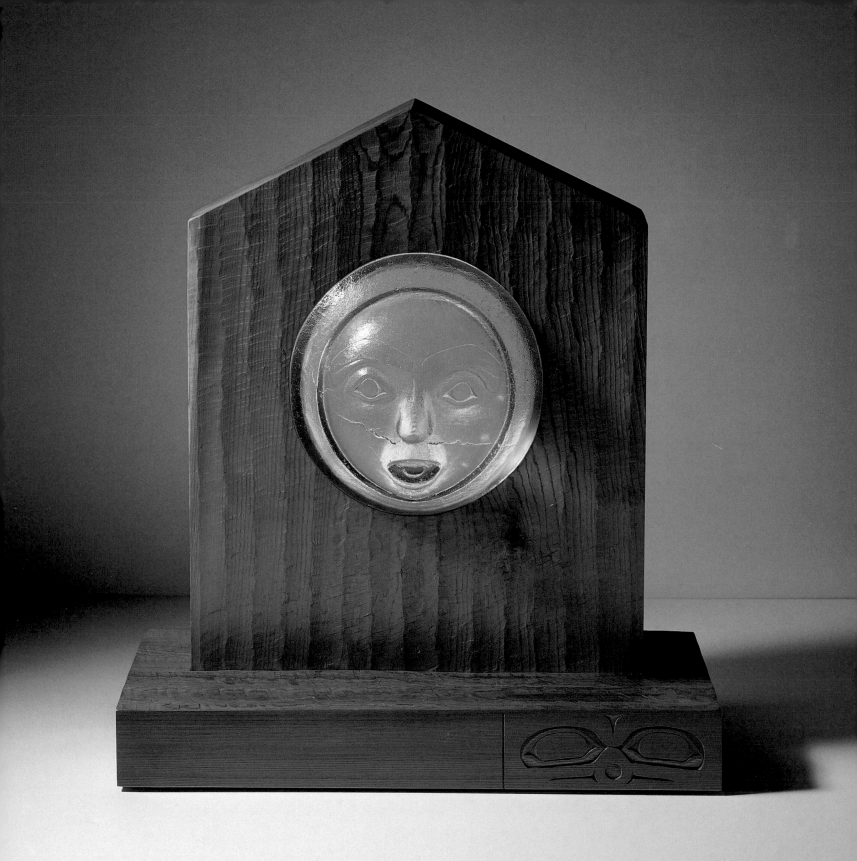

C O N R A D H O U S E
(1956–2001)

Lightning Prayersticks Protected by Turquoise Mountain Lions
Pyrex glass rods-sandblasted; ceramic attachments, acrylic, turquoise,
white shell and heishi beads, abalone, and non-endangered species
parrot feathers
11 x 2 x 1 inches
1989

Collection of John and Carolyn House

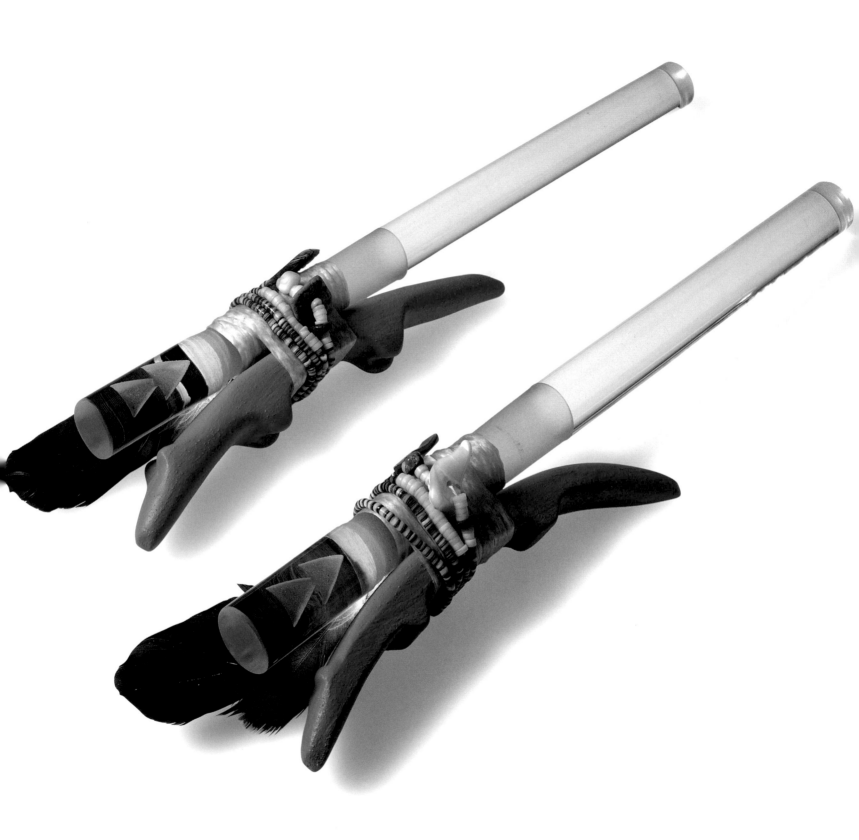

CLARISSA HUDSON

Egyptian Tlingit-Headdress
Austrian crystal beads, Czech crystal fire polished glass beads,
glass discs, smoked moose hide, base metal discs, seed beads
7 x 15 inches
2002

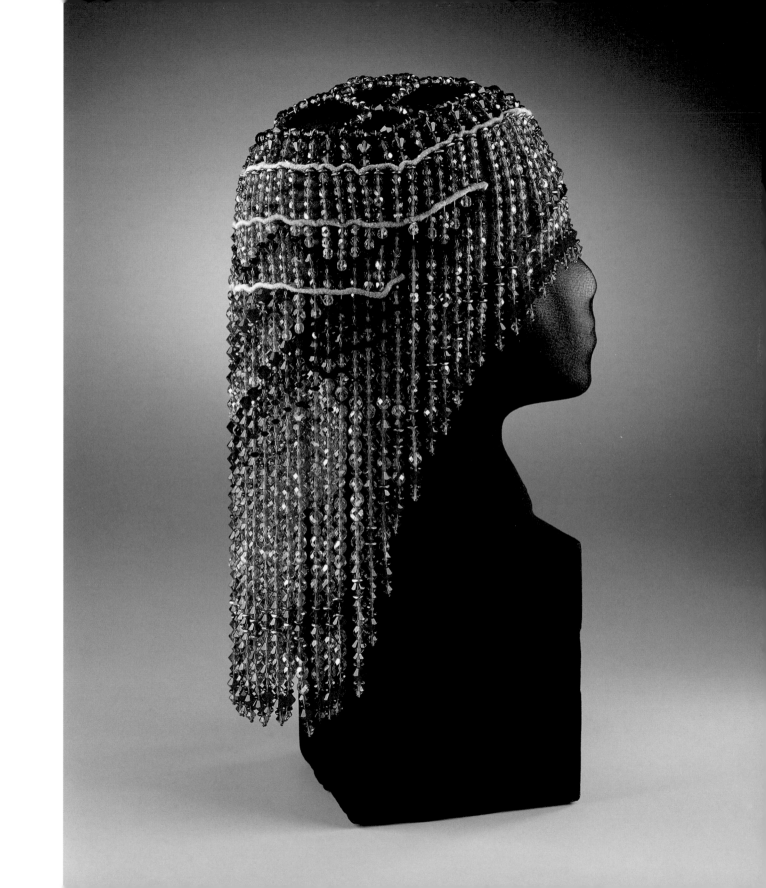

TONY JOJOLA

Evening Colors
Free blown glass with drawing and stamps
13 $^1/_2$ x 9 inches
2001

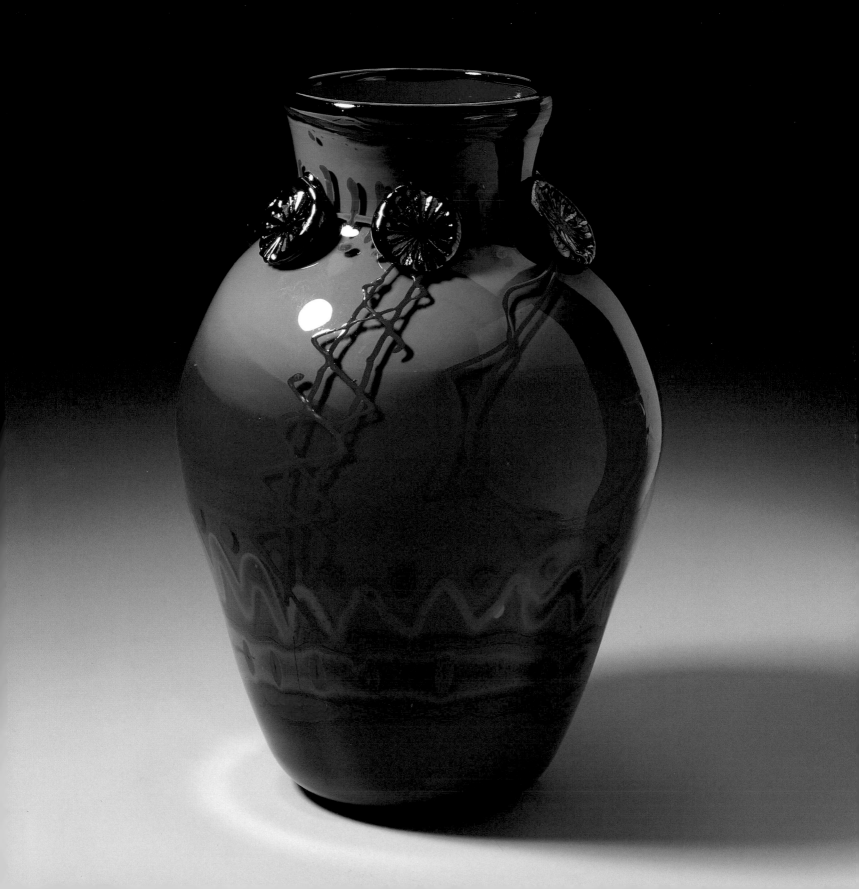

RAMSON LOMATEWAMA

Matrix of Life Becoming
Blown glass with 24 karat gold leaf
8 x 14 inches
1997

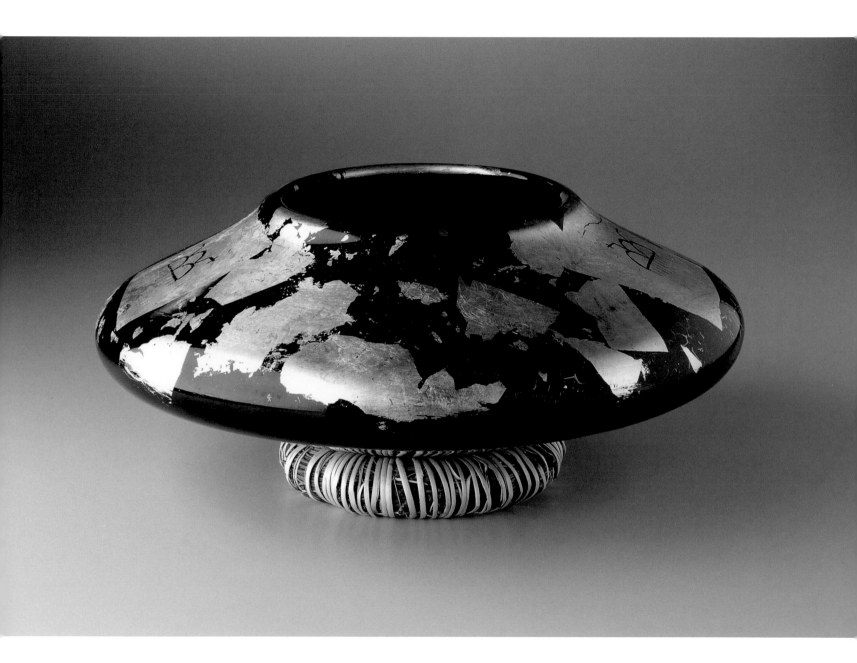

ED ARCHIE NOISECAT

Baby Frog
Blown and sandcarved glass
11 x 10^3/$_4$ x 8 inches
2001

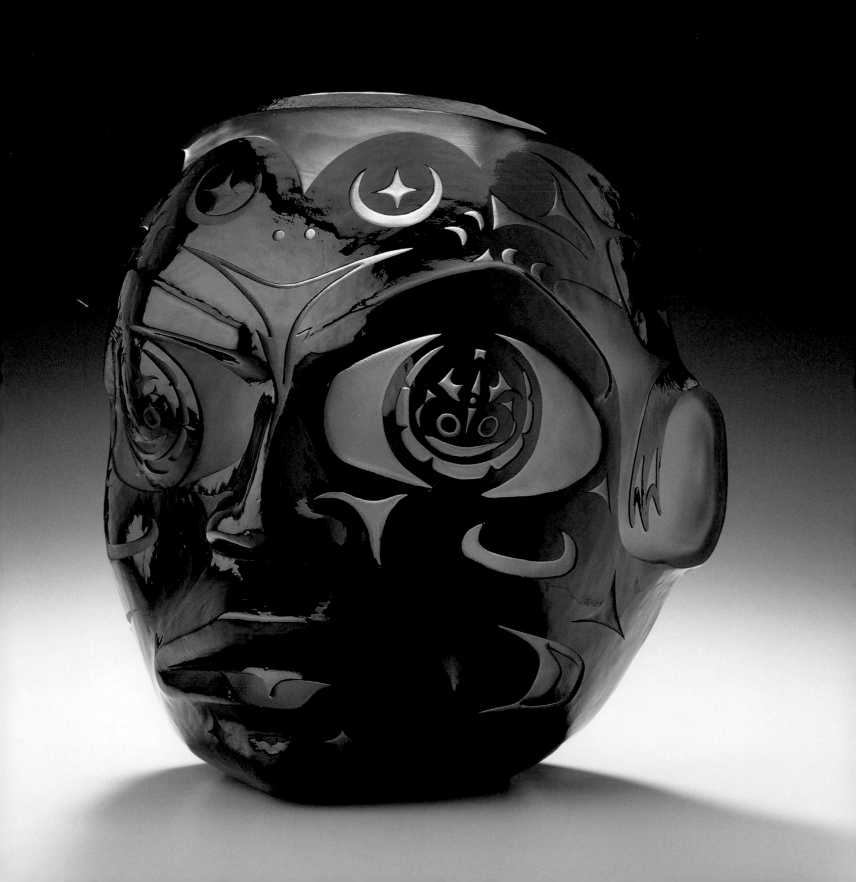

MARTIN OLIVER

Facing You
Cast glass, polished dichroic glass, with steel stand
28 x 13 x 6 1/2 inches
2002

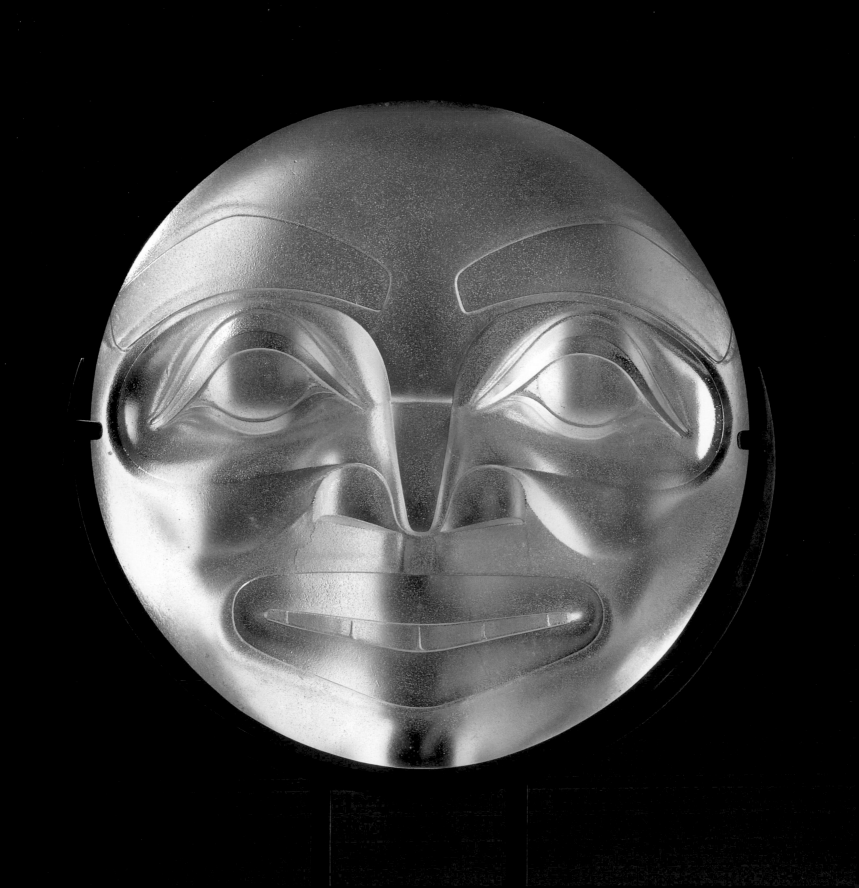

SHAUN PETERSON

Defining Wolf
Sandblasted glass, carved western red cedar, stainless steel, acrylic
pigment
35 x 3 inches
2002

Photograph courtesy of Stonington Gallery, Seattle

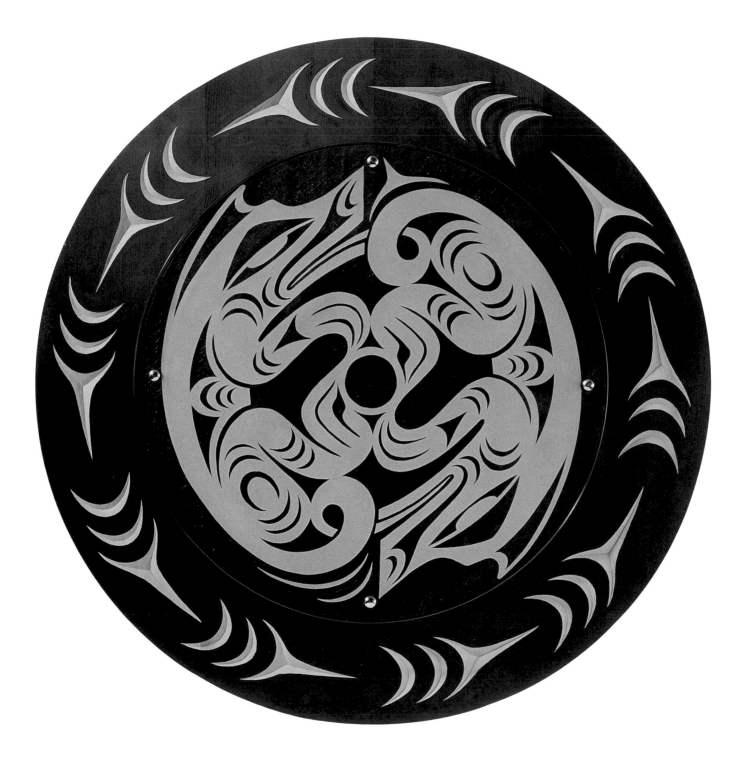

SUSAN A. POINT

Mythical Bird
Slumped and carved glass, painted and carved yellow cedar base, and
painted maple wooden spindle
24 x 24 inches
2002

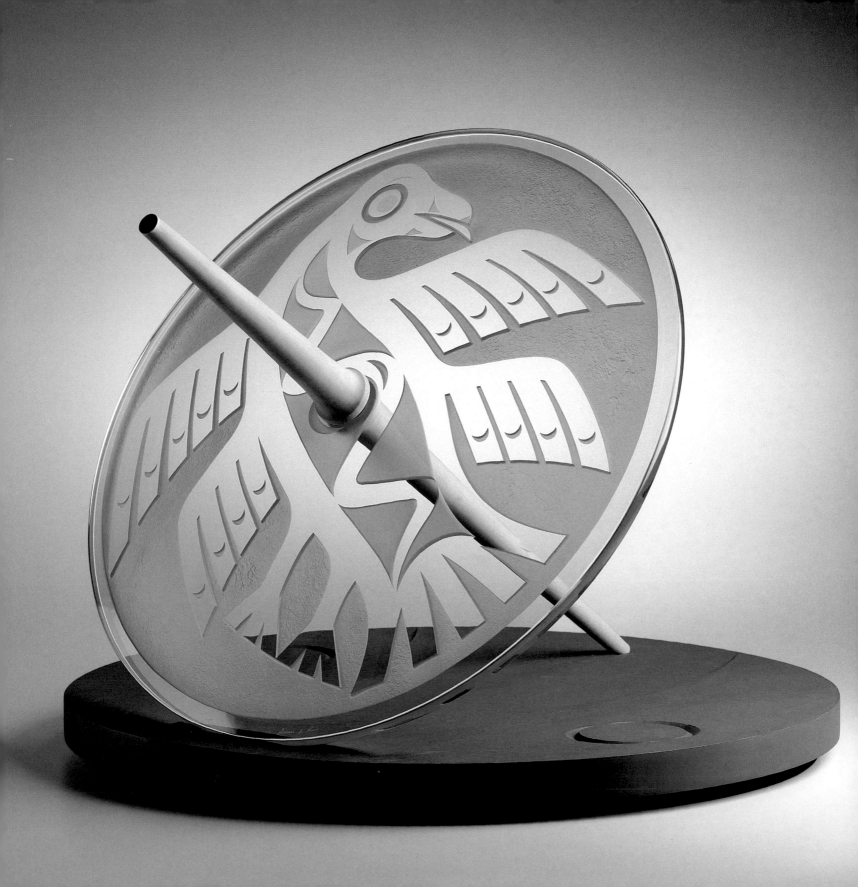

WAYNE G. PRICE

Tlingit Bear Visions
Carved red cedar, glass, acrylic
7 x 7 inches
2002

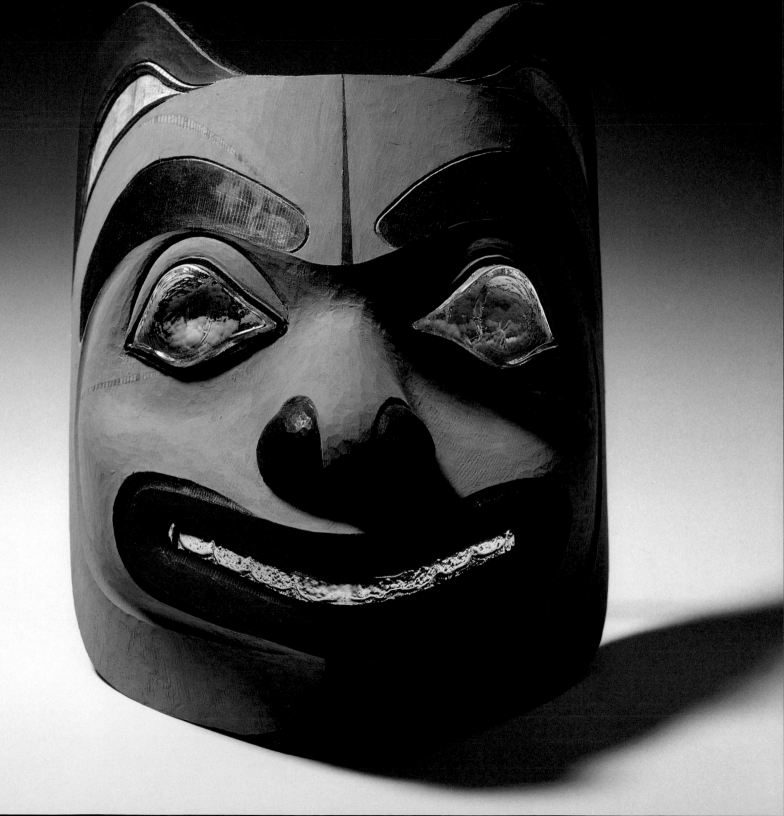

PRESTON SINGLETARY

Raven Steals the Moon
Blown and sandcarved glass
16 $\frac{1}{2}$ x 9 inches
2002

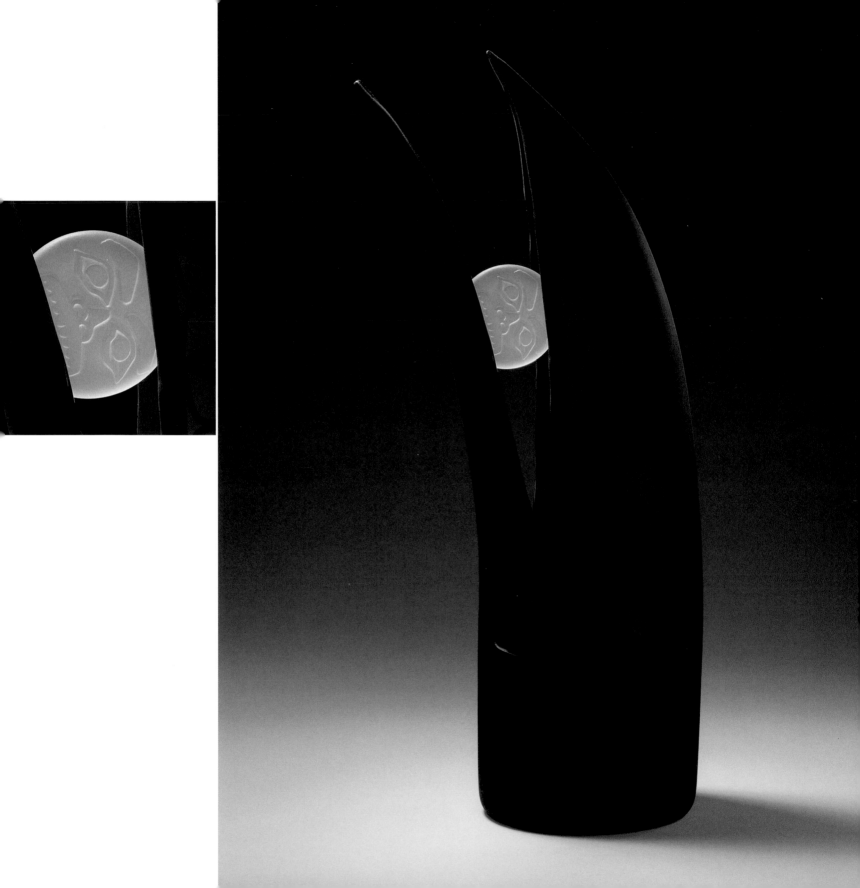

DAVID SVENSON

Touched by the Better Angels of Our Nature
Carved polychromed wood, glass, neon
29 x 16 x 16 inches
1992

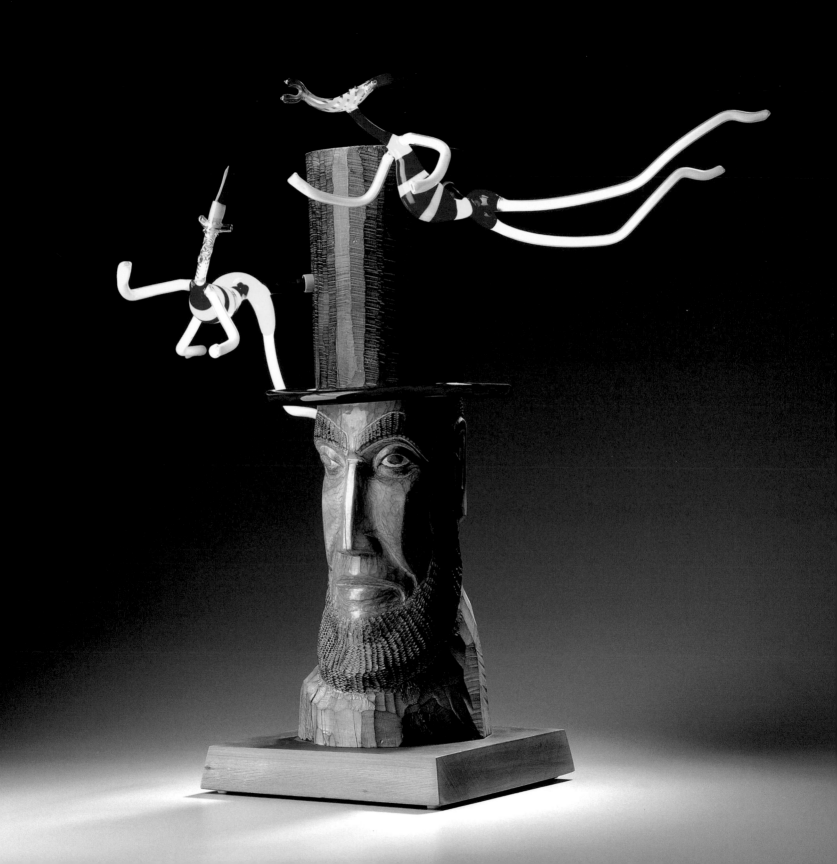

ROBERT JOHN TANNAHILL

Big Mouth, False Faces Series
Blown glass and carved wood, bound with copper wire
13 x 5 ¹/₂ inches
2001

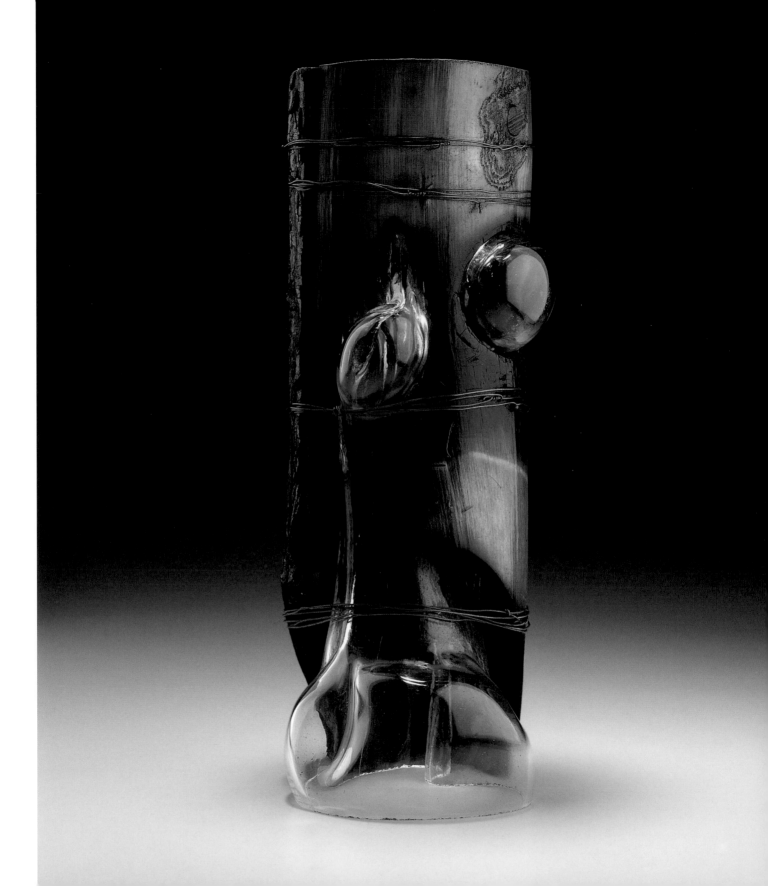

C.S. TARPLEY

Doumbeque
Blown glass, electroformed copper, goat skin
12 $\frac{1}{2}$ x 9 inches
2001

Courtesy of Kiva Fine Art of Santa Fe

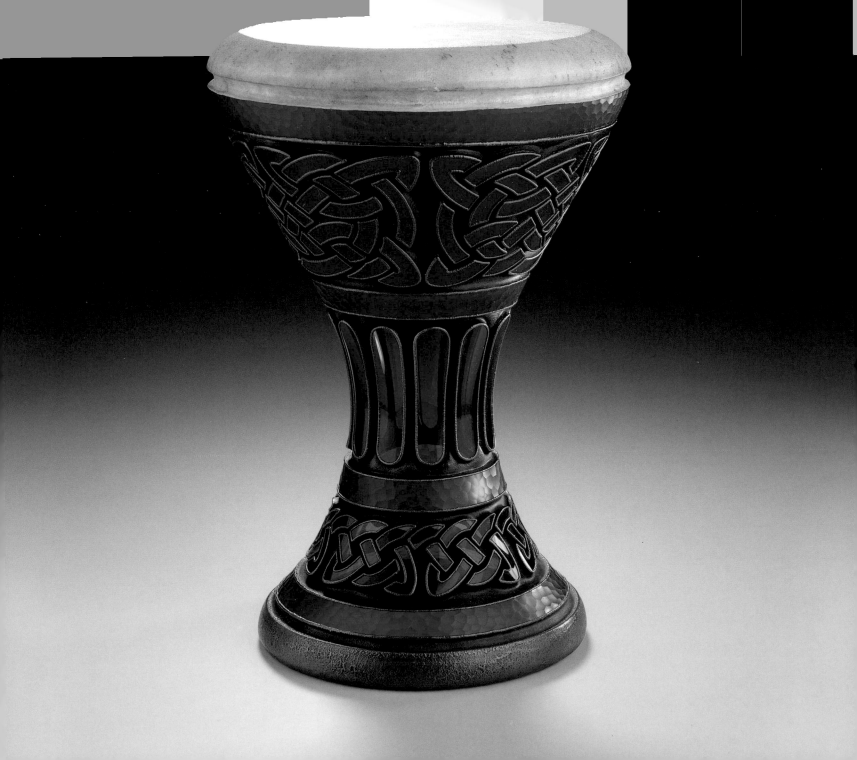

Larry Ahvakana
INUPIAQ

Ahvakana was born in Fairbanks, Alaska and raised in Barrow and Anchorage. He attended the Institute of American Indian Arts (1966-69), Cooper Union School of Art (1969-70), and received his BFA from the Rhode Island School of Design in 1972. Ahvakana was the head of the Sculpture Studio at the Visual Arts Center in Anchorage (1975-77) and taught sculpture and glass at the Institute of American Indian Arts (1977-80). Since 1980 he has been working full-time as an artist. His artwork has been collected by several museums including the Alaska State Museum, Juneau; the Anchorage Museum of History and Art, Alaska; the Institute of American Indian Arts, Santa Fe; the Portland Art Museum, Oregon; and the Washington State Arts Commission, Olympia.

All my life, I was surrounded by my culture and my people, the Inupiaq of Northern Alaska. The dances and songs of the Inupiaq tradition is the oral history of my people. It is an emotional interpretation of our respect and involvement within the environment of the North Slope of Alaska. Through my work, I can express/create my ideas of tradition, those feelings of being part of a society that is thousands of years old, with contemporary influences from artists such as Allan Houser, Fritz Scholder, Charles Loloma, Paul Klee and Wassily Kandinsky. I continually gain insight, direction, and physical or emotional strength through the stories of how the Inupiat defined their total subsistence lifestyle with shamanism, ceremony, and the natural cycles of Arctic living.

Marcus Amerman

CHOCTAW

Amerman's artwork has appeared in major exhibitions nationally and internationally, including at the National Museum of the American Indian; National Cowboy Hall of Fame, Oklahoma; and in Nagoya, Japan, Oxfordshire, England, and Khabarovosk, Russia. His artwork is in the collections of many other prestigious institutions including the Museum of Indian Arts and Culture, Santa Fe; National Museum of the American Indian, New York; the Heard Museum, Phoenix; and the Portland Art Museum. Articles about him and his artwork have been published in *American Indian Art Magazine, American Craft Magazine, Beadwork Magazine, Native Peoples Magazine, The New York Times,* and *The Wall Street Journal.*

I've lectured on a concept of mine called Art is War. Back in the old days young Indian men would go to war to gain honor and prestige, and form their place in the world of the tribe. Now that we don't really have wars, I see art as a way of hunting, providing food for yourself, and gaining honor and wealth. I used to say just selling your art was like hunting; just something you did to put food on the table. Showing in a gallery was akin to stealing horses; gaining wealth. To have your work hung in museums or to be asked to lecture was more like honors won in battle.

Brian Barber

PAWNEE

Barber was born in Flint, Michigan. He received his BFA in glass from Ohio State University in 1999 and attended the Penland School of Crafts, North Carolina in 2000. Barber was awarded the Hauberg Scholarship at the Pilchuck Glass School in 2001. He has been working at Manifesto Glass in Seattle, Washington, since 2001.

As an artist I am working to dilate my frame of reference by materializing ideas so they can be more closely examined. Some of these ideas come from my heritage as a Native American as well as the other cultures I was exposed to living in Europe as a child. My aim is to draw parallels between these cultures and explore that which speaks of a more universal human condition.

Michael Carius

SIBERIAN Y'UPIC

Carius grew up in Anchorage, Alaska. He is a member of the Emperor Goose Clan. He received his BFA in Metal Design from the University of Washington in 1993. He has also studied glass at the Pratt Fine Arts Center, Seattle, Washington, and the Pilchuck Glass School, Stanwood, Washington. Carius began sculpting hot glass, welding steel, and casting bronze in 1997. He was awarded the PONCHO Scholarship at the Pilchuck Glass School in 2001.

I am researching pre-European contact Eskimo culture. After learning as much as I could from my family, most of this knowledge now comes from early explorers. They had enough forethought to collect and record this information. I am interested in how morals and values are transmitted in the stories and beliefs. My work includes aspects of shamanism including animism, transformation, inua (the spirit that resides in all things), and the rituals that connect and synchronize this world with others. I want the elements in my sculptures to work synergistically to express those concepts. By reinterpreting the myths and legends in non-traditional materials such as glass, steel and bronze (with a certain amount of Western art influence), I have a deeper understanding of the spirituality of my ancestors.

Joe David

NUU-CHAH-NULTH

David was born in 1946 at the village Opitsaht, on Meares Island off the west coast of Vancouver Island. He is a member of the Tia O Qui Aht, one of fifteen Nuu Chah Nulth tribes. He was given the name of Ka-Ka winohealth meaning "Supernatural White Wolf Transforming into Killer Whale" by his father when he was twenty-two, as recognition of his commitment to carving as a way of participating in his heritage. David began carving Northwest Coast forms in the 1960s while living in Seattle, where he produced his first works after seeing photographs of old artifacts in local museums. In 1971 he met Duane Pasco, a noted carver, and Bill Holm, a professor of Northwest Coast Indian art. He began to study under them gaining a deeper understanding of the formal design elements of the medium. Since then, David has continued to investigate the different styles and forms of Northwest Coast art, combining the classical forms of Northern designs with his own freer, tribal styles. He has come to be recognized as one of the foremost designers in two dimensional and sculptural forms.

John Hagen

ALASKAN NATIVE

Hagen is a commercial fisherman, master carver, and father of three.
He has been carving at the Alaskan Indian Arts, Inc. since 1962,
where he was trained by noted Northwest Coast Master Carvers
Leo Jacobs, Sr., Edwin Kasko, Wes Willard, with the help of Carl
Heinmiller. Hagen recently completed two large family history totem
poles incorporating glass elements, for two collectors. In 2001 Hagen
collaborated with David Svenson and Preston Singletary to produce
the Founders Totem Pole for the Pilchuck Glass School. The carved
red cedar totem pole incorporated glass pieces cast from original carv-
ings. Hagen has begun incorporating glass into his traditional art.

I like the way glass as a medium allows light to enhance my work.

Conrad House

NAVAJO (1956–2001)

House attended State University of New York, Fulton-Montgomery Community College, Johnstown, New York (1974–76) and University of Portland (1977–78). He received a BFA with a minor in Political Science from the University of New Mexico (1980) and an MFA from the University of Oregon (1983). He also studied surface decoration, pâte de verre, sandcast, coldworking, and stained glass painting techniques at the Pilchuck Glass School, Stanwood, Washington (1986–90). House worked in many media during his life, including drawing and painting, collage, sculpture, ceramics, textiles, beadwork, and glass. He was awarded many honors, including the Heard Museum Guild Award in 1996 and First Place and Best of Division at the Santa Fe Indian Market (1994–1998). His artwork has appeared in many major exhibitions nationally and internationally, including the Navajo Nation Museum, Window Rock, Arizona; the Museum of Fine Arts and the Museum of Indian Arts and Culture in Santa Fe; the National Museum of the American Indian, and American Indian Community House in New York; and in Manchester, England, Geneva, Switzerland, and Rabat, Morocco. His artwork is in the collections of many other prestigious institutions, including the Institute of American Indian Arts Museum, Santa Fe, and the National Museum of the American Indian, New York. In 1994 he was guest interpreter and author for the ground-breaking exhibition and catalogue *All Roads are Good: Native Voices on Life and Culture* at the National Museum of the American Indian.

My concerns as an artist reflect life and all its complexities, from color and textural relationships, to confronting contemporary issues, such as the impact of AIDS, political beliefs, spiritual values, environmental destruction, trips to Europe, and sweet love relationships. The list goes on, but are all interrelated. My concerns can change as drastically as the many mediums I play with, from pastels, to clay, to glass, to beads, to collages, to paints, then back to pastels. Freedom of choice is essential.

Clarissa Hudson

TLINGIT

Hudson was born in 1956 in Juneau, Alaska. Her mother is Tlingit from the village of Hoonah, Alaska, and her father is Filipino American from Seattle, Washington. She attended the Institute of American Indian Arts, Santa Fe (1988–89), and studied with Preston Singletary and David Svenson at the Pilchuck Glass School, Stanwood, Washington, in 2001. Hudson also worked on the Pilchuck Founders Pole. Her recent exhibitions include *Chilkat & Ravenstail Weaving*, Seattle Art Museum, and *Blanket Statements*, Banff Center for the Arts. Her artwork has also been exhibited at the Heard Museum, Phoenix; Alaska Native Heritage Center; and Institute of American Indian Arts, Santa Fe. She has received many honors, including the Heard Museum Guild Best of Show Award in 2001 and many awards at the Santa Fe Indian Market for her painting, weaving, and sculpture, including Best of Show in 1994. She is an experienced Chilkat weaver, who has taught numerous classes in Alaska, Canada, and Colorado. Articles about her and her artwork have been published in *Native Peoples Magazine, Native Artist, Cowboys and Indians,* and *Southwest Art.*

you know, when Clarissa is asked
to talk about herself
she is amazingly dumbfounded
and her mind fumbles with the ball of speech
of who what where does she begin
the fragment of a story of her simultaneous lives
where she may dribble, shooting for a basket of space,
movement, and two points
while the audience awaits for her to at least
begin scrabbling for nine yards
knowing fully well that she can talk talk talk talk
if given eighteen yards
she'll just go for a touchdown
and we can all go home at half-time

Tony Jojola

ISLETA PUEBLO

Jojola was born on the Isleta Pueblo in New Mexico. The grandson of a potter and a silversmith, his first artwork was in clay and today his glass vessels are embellished with silver stamps made with tools from his grandfather's collection. He studied at the Institute of American Indian Arts in Santa Fe, where he first learned glass blowing techniques in the 1970s. He received further training at the Haystack Mountain School of Crafts in Deer Isle, Maine, and at the Pilchuck Glass School in Stanwood, Washington, where he served as a studio assistant to Dale Chihuly. He has also studied with glass innovator Harold Littleton at the University of Washington. Jojola is a founder of the Taos Glass Arts & Education program, which opened in 1998. His art has been collected by the Denver Art Museum, the Institute of American Indian Arts, the Albuquerque Museum of Fine Arts, and the Contemporary Museum of Fine Art in Helsinki, Finland. The artist enjoyed a retrospective exhibition at the Wheelwright Museum, *Born of Fire: Works in Glass by Tony Jojola*, November 12, 2000–April 22, 2001. The exhibition featured sixty-six vessels created between 1980 and 2001. His artwork was also featured in a one-man show at the National Glass Museum in Finland, where he also conducted classes at the Department of Ceramics and Glass of the University of Art and Design.

There's a revolution happening on the pueblo. What we're really starting at Taos is a national Native American glass-art movement.

Ramson Lomatewama

HOPI

Lomatewama was born into the eagle clan in 1953 and grew up on the Hopi Reservation. He is an artist, poet, educator and consultant in cultural anthropology, who lives outside Flagstaff, Arizona, with his wife, Jessica, and their children. Their on-going commitment to Hopi lifeways and ceremonies takes them back to their Native land throughout the year. Lomatewama received an AA from Northland Pioneer College (1979) and a BA from Goddard College (1981) in creative writing and philosophy. He creates blown glass vessels, leaded stained glass forms, and kachina dolls, all of which are influenced by his Hopi heritage. He has received many honors, including the Arizona Senators Art Award in 1989 and the American Indian Arts Foundation Award in 1987. His most recent work is published in *Art of the Hopi*. The artist has also published three books of poetry.

All cultures share four common elements—values, laws, language, and the arts. And, although each facet has importance in its own right, it is through the arts that we gain more understanding of those values, laws, and languages: those concepts and structures which help to define the identities of all people. As an artist, my continuing search for a greater appreciation and respect for others can only come through the practicing of my own creative endeavors. It is with this in mind that I have chosen the visual and literary arts, the study of myth, and the educating of others to continue my quest for greater awareness.

Ed Archie NoiseCat

SALISH/SHUSWAP AND STLATLIMX

NoiseCat grew up on a small reserve in central British Columbia. He is a 1986 Honors graduate of the Master Printmaker Program at the Emily Carr College of Art and Design in Vancouver, British Columbia. He now lives in Santa Fe, New Mexico. Trained as a fine art lithographer, he worked at several print shops in New York before becoming a full-time independent artist in 1989-90. It was at this time that he began to work in three dimensional art forms. He has participated in two dozen exhibitions since 1988 in Santa Fe, Phoenix, Seattle, Vancouver, Philadelphia and Los Angeles. He was named Best of Division winner, Diversified Art Forms, Judge's Choice, at the 43rd Annual Heard Museum Indian Art Show, Phoenix, Arizona.

I love to work on a grand scale. Many of my pieces incorporate transformational elements that relate to the Supernatural abilities prevalent in the spiritual and pre-contact history of my people. I recently introduced several new lines of work: sculptural jewelry in silver, gold and semi-precious stones; art furniture that joins the structural forms of the Northwest long-house with traditional Japanese woodworking techniques; and glass work including blowing, casting and carving. My most recent works in glass have involved kiln casting at Finley Design Studios and blown masks that were a collaborative effort with Tlingit glass blower Preston Singletary. Although some might have difficulties in keeping up with so many techniques, I find that the variation in aesthetic stimuli and the challenge to master these new disciplines helps keep my ideas fresh and my work interesting. My goal as an artist would be to expand the vocabulary of neo-aboriginal art and soften the barriers into the mainstream.

Marvin Oliver

QUINALT/ISLETA PUEBLO

Oliver received a BA at San Francisco State (1970) and an MFA from the University of Washington (1973). He is an associate professor of American Indian Studies at the University of Washington, where he also serves as curator of Contemporary Native American Art at the Burke Museum. His glass art, prints, masks, helmets, and wood panels fuse ancient forms with contemporary aesthetics. His monumental sculptures in the form of totem poles and stylized whale fins created from cedar, bronze, cast glass, and enameled steel are exhibited throughout the United States, Canada, and Japan. Oliver is an active member of his community who has served as an advisor and juror to many public exhibitions and organizations, including Regional Advisor to Atl Atl, member of the Artist Council Planning Committee for the first Northwest Indian Art Market, and Percent for Public Art in Seattle. He has been honored with a National Endowment for the Arts Fellowship (1988) and the Distinguished Alumnus Award by the University of Washington.

My works are formulated by merging the spirit of past traditions with those of the present, to create new horizons for the future.

Shaun Peterson

SALISH/PUYALLUP AND TULALIP

Peterson is an artist and teacher, who reaches community groups and school children in art exhibitions and demonstrations. He taught Native Art and Culture at the Chief Leshi School in Puyallup in Washington from 1996 to 1999. His artwork combines traditional and contemporary materials and styles from several tribal groups along the Northwest Coast region. He creates paintings, serigraphs, mono prints, wood sculpture, and glass art. He has created logos for the Tulalip Canoe Family and the Puyallup Tribal Health Authority. His art has been collected and exhibited throughout the state of Washington. He was a member of the team that created the Founders Totem Pole at the Pilchuck Glass School in 2001.

Through the training and guidance of many Northwest Coast artists, I have been able to become part of the circle, so to speak. Artists including Steve Brown, Bill Holm, Greg Colfax, Loren White, with Joe and George David have been largely influential. They have allowed me to seek their support and guidance as a young Native Northwest Coast artist growing amongst the group. In addition, I am largely active in continuing our traditional ceremonies and support a number of events that help bring back to our youth the gift of cultural pride.

Susan A. Point

COAST SALISH

Point was born in Alert Bay, British Columbia, in 1952 and lives in Vancouver. She began her art career in 1981 in precious metals, serigraphs, wood block prints, and acrylic paints. She adapts traditional Coast Salish art forms to contemporary designs and materials to create her highly personal style. Point has been awarded numerous public art commissions, including building facades and large sculptures, which she creates in stainless steel, glass, bronze, concrete, wood, terra cotta and forton casting. Her artwork has been exhibited and collected throughout Canada, the United States, and Europe, including the University of British Columbia Museum of Anthropology, the Canadian Museum of Civilization in Ottawa, the University of Washington, the Heard Museum in Phoenix, the Wheelwright Museum in Santa Fe, the Denver Art Museum, and Volkerkundemuseum der Universitat Zurich.

Coast Salish art is relatively unknown to most people today, as it was almost a lost art form after European contact—the reason being that Salish ands were the first to be settled by the Europeans, which adversely affected my people's traditional life-style. I have spent a great deal of my time, as a Coast Salish artist trying to revive traditional Coast Salish art. Although most of my earlier work is very traditional, today I am experimenting with contemporary media and themes. However, I still incorporate my ancestral design elements into my work to keep it uniquely Salish. Sometimes I address issues of gender conditioning as well as social and economic conditions.

Wayne G. Price

TLINGIT

Price began his career in carving at the Alaskan Indian Arts Inc., in 1971. Working with artists Leo Jacobs, Ed Kasko, John Hagen, Clifford Thomas, and Jenny Lyn Smith, Price gained the knowledge of how to make tools and design two and three dimensional art of the Northwest Coast, emphasizing the style of the Tlingit Indians. Price creates totem poles, masks, rattles, spoons, bentwood boxes, canoes, and dance regalia. Working on totem poles throughout the Southeast since 1972, Price has earned the reputation as Master Carver. His totem poles can be found throughout Southeast Alaska as well as Japan and Seattle. In 2000 he completed a twenty-foot canoe for the Alaskan Native Heritage Center. In 2001 Price was one of the main carvers for the Pilchuck Glass School's Founders Totem Pole, where he learned to take traditional design into a new medium.

Preston Singletary

TLINGIT

Singletary was born in San Francisco in 1963 and lives in Seattle, Washington. He has studied at the Pilchuck Glass School in Stanwood, Washington, with Lino Tagliapietra, Cecco Ongaro, Benjamin Moore, Dorit Brand, Judy Hill, Dan Daily, Pino Singiretto, Dante Marioni, and Stanislav Labinsky, among others. In addition, he has worked with glass artists in Sweden, Italy, and Finland. His blown and sandcarved glass sculptures have been collected by the Seattle Art Museum, the Mint Museum of Art+Design in Charlotte; the Museum of Natural History in Anchorage, Alaska; and the Handelsbanken in Stockholm. Singletary is a member of the Board of Trustees for the Pilchuck Glass School. He collaborated with a team of artists to create and install the Founders Totem Pole at the Pilchuck Glass School in 2001.

The work that I do today is a progression of my accumulated experience, and a process of discovery. It is my attempt at transforming an ancient design style to the non traditional medium of glass. As I have worked to understand how to approach this design system, and what these designs mean to us as Northwest Coast people, my fascination has brought a new dimension to my life. Since I grew up outside of the region where this traditional art style originated, it has been hard for me to say "we" instead of "they" when I talk about my work. I do not wish to present my work from an anthropological point of view. I have reached out to other Native artists and scholars to comment on my work so that I may learn from them, and I am grateful for the support I have received from them. I like to think that there is a genetic memory that exists in us, and I like to think that this shows me ways to develop new designs. I sometimes hope that my work can be appreciated on other levels not associated with ethnic art, while at the same time it is that very thing that gives it power. I can only hope that I can one day achieve the same level as the ancients who developed this art style.

David Svenson

Svenson lives in Wrightwood, California. He is a graduate of Pitzer College, in Claremont, California, where he received a BA in Art in 1980. He travels the world teaching neon sculpture: at the Academy of Art College in San Francisco; the Pilchuck Glass School in Stanwood, Washington; Haines, Alaska; Tokyo, Seto and Osaka, Japan; and Taiwan. He has trained since his teenage years in the field of Northwest Coast totem carving. He continues to work with the Tlingit Indians on monumental carving projects at Alaska Indian Arts, Inc., in Haines, Alaska. His most recent project was the Founders Totem Pole at the Pilchuck Glass School, which incorporated cast glass and neon in the carved wood pole. His artwork has been included in numerous museum exhibitions, including the Museum of Neon Art in Los Angeles; the Grove Gallery, University of California, San Diego; the Museum of Craft & Folk Art, San Francisco; and the Sheldon Museum, Haines, Alaska, among others. He has also curated glass and neon art exhibitions, in the United States, Japan, and Taiwan. His art work has been published in *Native Peoples Magazine, National Geographic World, Hsinchu International Glass Art, Contemporary Lampworking,* and *Who's Who in Contemporary Glass Art.* Svenson, a non-Native, is an influential teacher at the Pilchuck Glass School and is featured in this exhibition at the request of his students, who honor him.

My approach to art and life are one and the same.
I strive for some sense of beauty, but not without question.
Working with my hands and challenging my ability is what I live for.
For me the results are less important than the process of making.
Sharing and crossing cultural ideas, techniques and food brings
me satisfaction.

Robert John Tannahill

MOHAWK / METIS

Tannahill was born in 1970 in Simcoe, Ontario, Canada. He received a BA from Sheridan College, School of Craft and Design in Ontario, Canada, in 1998 and is an MA student at the University of Art and Design in Helsinki, Finland. His artwork has been exhibited at the University of Art and Design in Helsinki, the Lohja Museum in Lohja, and the Finnish Glass Museum in Riihimäki, Finland; the Ebeltoft Glass Museum, Denmark; and in Barcelona, Spain. He has received awards from the Pilchuck Glass School Scholarship, the National Aboriginal Arts Foundation, and the Canadian Native Arts Foundation. He participated in the creation of the Founders Totem Pole at the Pilchuck Glass School in Stanwood, Washington.

My work right now is divided between two forms; the totem and the self-portrait. I use the totem to give voice to the Mohawk ghosts I no longer hear. My great grandmother got excommunicated from her tribe for marrying a white man. She didn't teach her language or stories to her children so they disappeared overnight. Hopefully these glass totems are echoing or reinventing those lost family stories. The self-portraits represent the different characters my brother and I were labeled or were influenced to become by different people in different towns. On average I changed towns every three years in my life. My view of myself was forced to adjust to fit into new surroundings. There is a deception to identities, to exteriors. Hopefully the self-portraits are an honest communication of things I should have said and feelings I hid.

C. S. Tarpley

CHOCTAW/CHICKASAW

Tarpley was born in Santa Fe, New Mexico. He is of Celtic, German, Irish, Choctaw, and Chickasaw descent and considers himself a "multicultural artist." As a teenager, he spent his early years in Santa Fe working as a lapidary, foundryman and metal fabricator. Later he studied glass-making at the Pilchuck Glass School in Stanwood, Washington. His work now combines glass and metal. Tarpley first envisioned blowing glass into metal, but his experiments were not successful until he learned about electroforming, a process that electrically binds the metal to the glass.

One of the aspects of my work that I like to point out is that every design I use is universal and appears in European and African traditions as well as Native American. The multicultural nature of these motifs appeal to my "sense of place" in our modern culture and allow me to honor the multiple nationalities and ethnicities that comprise my family. In my work people can expect to see "Celtic Knots" that are in fact images derived from Mayan temples in Veracruz. They will also see step and fret patterns called "Greek Keys" and Egyptian feather/palm leaf motifs that are identical to Pre-Columbian Pueblo designs. What I seek to demonstrate is that many of the motifs that are commonly referred to as Greco-Roman or Indo-European in our Western body of thought are, in fact, truly universal and have been independently developed by other cultures separated by vast oceans and thousands of years. What is even more intriguing to me is the fact that even though a particular design may have an identical New World counterpart, it will have a meaning and significance that varies from culture to culture. With this in mind, it is possible for two individuals from two very different cultural backgrounds to regard the same work of art and come away from the experience feeling that the piece spoke directly to their own personal sense of history and tradition. It's all a matter of cultural context.

The Founders Totem Pole at the Pilchuck Glass School

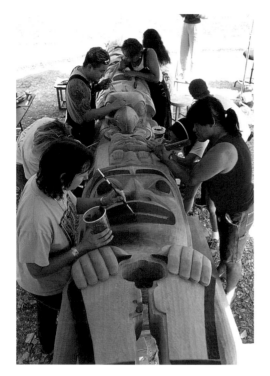

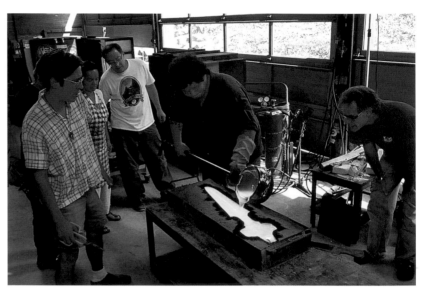

The Founders Totem Pole at the Pilchuck Glass School was raised in commemoration of the school's thirtieth anniversary in August 2001. The idea for the pole that portrays and honors the founders was proposed by artists Preston Singletary and David Svenson. The pole was carved from a twenty-foot red cedar log at Alaska Indian Arts, Inc. in Haines. Master carver John Hagen led a dedicated team of carvers including David Svenson, Wayne Price, and Joe David. Artists in residence at the Pilchuck Glass School painted the pole and incorporated glass and neon elements. Natives and non-Natives worked together in a collaborative effort to finish the pole that is a striking blend of materials, technologies, and cultures.

At the base of the pole, shown as a high ranking chief, is the figure of John Hauberg, who donated the land on which Pilchuck is built. The glass dagger he holds is a replica

Photographs by Russell Johnson

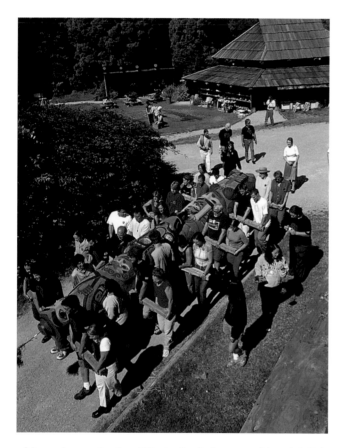

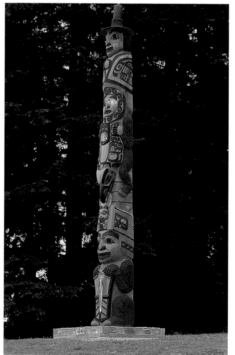

of the one he repatriated to a Tlingit tribe. In the center of the pole is Dale Chihuly, wearing a glass and neon eye patch, holding Raven with the glass Sun Disc in his beak. Just as Raven brought light to the world in Northwest legends, so Chihuly is considered to have "lit the way" for many glass artists. At the top of the pole is a representation of Anne Gould Hauberg, shown wearing a ceremonial Chilkat Robe designed by Clarissa Hudson.

The Founders Pole raising ceremony included welcoming speeches and traditional prayers, songs, and dancing, under the direction of John Hagen and Joe David. A salmon feast and potlatch followed where, as custom dictates, guests received gifts for serving as witnesses to this historic event.

ROSLYN TUNIS

Taos Glass Arts and Education

Tony Jojola and Kathy Kaperick founded the Taos Glass Arts & Education program, which opened in 1998. It includes a 15,000 square-foot studio glass center, production shop, exhibition space and plaza on two acres of Taos Pueblo land in New Mexico. These images show Jojola hard at work teaching young people how to design and create glass art.

Forty percent of what happens is glass, sixty percent is social work. The kids require attention because they never got it anywhere else—but it works. Every day, they're more engaged.
Tony Jojola

Fire is a crucial element in glass-blowing, and it's [fire] always been an essential element in our tradition. People are taught to fear it, but fire has always been our friend.
Richard Deertrack, Taos Tribal Council

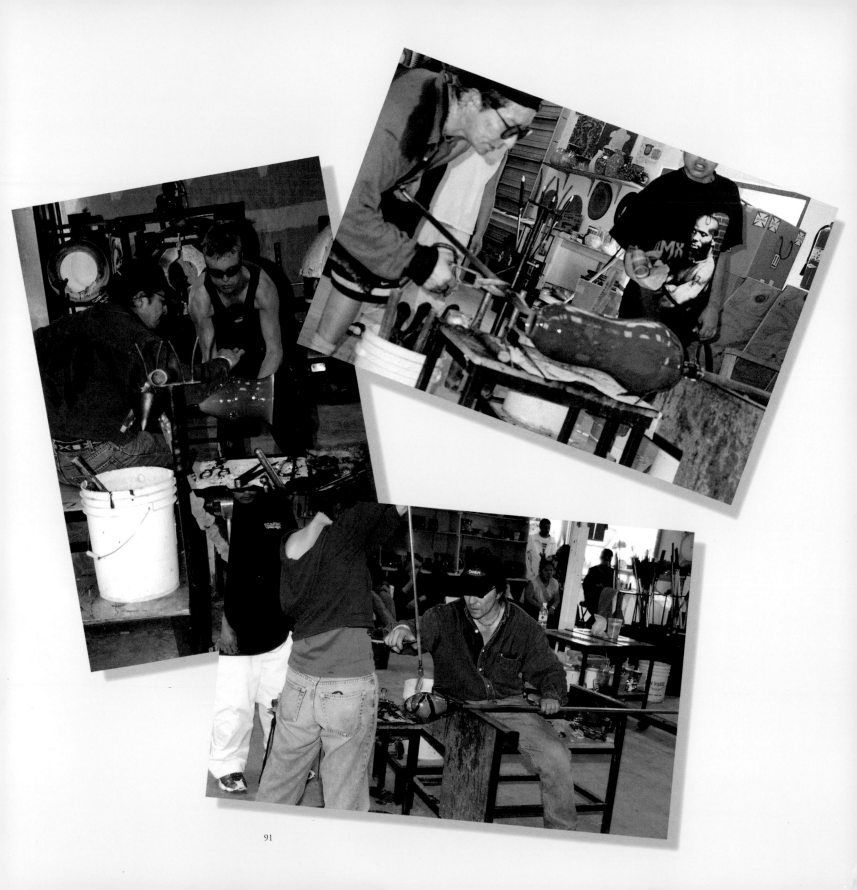

GLOSSARY

Dichroic: A type of manufactured glass, which has an ability to manipulate light in two different ways. Color is transmitted through the glass and complementary colors are reflected from the surface.

Electroform: A process by which glass is coated with metal by dipping it into an electrically charged solution.

Gather: The blob of glass picked up from the furnace as it adheres to the end of a hot blowpipe.

Fuse: To melt together two or more pieces of glass in a kiln.

Kiln cast: The use of a mold, usually plaster, filled with crushed glass, which is melted in a kiln to produce a solid glass form.

Laminate: To use heat or glue to join pieces of glass.

Lampwork: To melt glass rods over an open flame with a gas-oxygen burner or blowtorch.

Latticino: A technique of incorporating threads of opaque glass into a blown form.

Mold-Blown: Glass formed into a shape by being blown into a mold, usually made of wood, metal or plaster.

Neon: An inert gas, which is electrically charged in a glass tube.

Overlay: A thin layer of clear or colored glass on the outside of a piece.

Free blown or off-hand: Formed free-hand on the end of a pontil or blowpipe. No mold is used.

Pâte de verre: A French term, meaning "glass paste." The process of melting powdered glass or shards in a plaster mold in a kiln at high temperature.

Sandcarved: To blow or blast sand or carborundum onto a piece, which etches or blasts away layers of glass. Masking is used to create patterns.

Sandcast: To ladle hot glass into a mold made of special casting sand.

Slump: To allow sheet glass to slump into a mold when heated in a kiln.

Threads: Thin strands of glass, usually colored, which can be added to the glass in a variety of ways for different effects.

Underlay: A thin layer of clear or colored glass on the inside of a piece.

Wrap: A strand of glass applied hot to a vessel.

BIBLIOGRAPHY

Coe, Ralph T., *Lost and Found Traditions: Native American Art 1965-1985*, (New York: American Federation of Arts, 1986).

Furst, Peter T. and Jill L., *North American Indian Art*, (New York: Rizzoli International Publications, Inc., 1982).

Herman, Lloyd E., *Clearly Art: Pilchuck's Glass Legacy*, (Bellingham, Washington: Whatcom Museum of History and Art, 1992).

Jonaitis, Aldona, ed., *Looking North: Art from the University of Alaska Museum*, (Seattle: University of Washington Press, 1998).

Klein, Dan, *Artists in Glass: Late Twentieth Century Masters in Glass*, (London: Octopus Publishing Group, 2001).

Malin, Edward, *Northwest Coast Indian Painting: House Fronts and Interior Screens*, (Portland, Oregon: Timber Press, 1999).

McMaster, Gerald, ed., *Reservation X: The Power of Place in Aboriginal Contemporary Art*, (Seattle: University of Washington Press, 1998).

National Museum of the American Indian, *Creation's Journey: Native American Identity and Belief*, (Washington, DC: Smithsonian Institution Press, 1994).

Oldknow, Tina, *Pilchuck: A Glass School*, (Seattle: University of Washington Press, 1996).

Peabody Essex Museum, *Gifts of the Spirit: Works by Nineteenth-Century & Contemporary Native American Artists*, (Salem, Massachusetts: Peabody Essex Museum, 1996).

Yelle, Richard Wiford, *Glass Art: From Urban Glass*, (Atglen, Pennsylvania: Schiffer Publishing, 2000).

Zerwick, Chloe, *A Short History of Glass*, (New York: Harry N. Abrams, 1999).